POSTCARD HISTORY SERIES

Hightstown and East Windsor

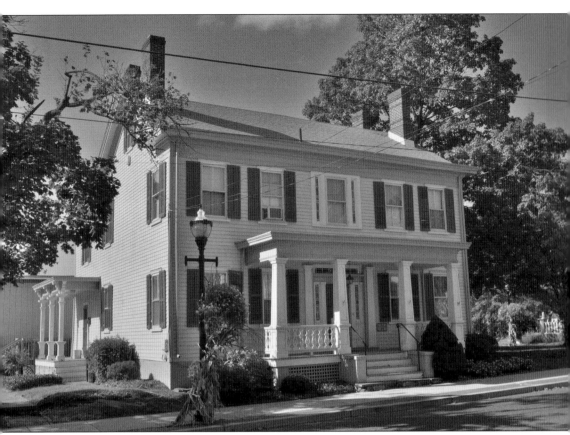

The Ely House, home of the Hightstown–East Windsor Historical Society, is located at 164 North Main Street. It is situated on the land settled in 1747 by John and Mary Hight, the "First Family" of Hightstown To learn more about the historical society, please visit their website at www.hewhs.com. (Author's collection)

ON THE FRONT COVER: Joseph Van Doren Davison's store opened for business in 1885 and was located on the Stockton Street side of Hutchinson Hall. Three of his sons—C. Herbert, Joseph B., and Howard C. Davison—worked there and eventually took over, enlarging it in 1910 and adding additional departments on the second floor. The two boys sitting in front of the store are Crosby Storer and Howard C. Davison. (Robert and Kathy Patten)

ON THE BACK COVER: The three-story brick building on the right has been a part of downtown Hightstown's silhouette since 1867, when it was inaugurated as Hutchinson's Hall. The first floor housed stores, the second a large public hall, and the third was used by the Free and Accepted Masons of Hightstown. In the early 1950s, the third floor was torn off during a hurricane, raining debris onto the sidewalk below and changing this view forever. (Robert and Kathy Patten)

POSTCARD HISTORY SERIES

Hightstown and East Windsor

Richard Harlan Pratt

ARCADIA
PUBLISHING

Published by Arcadia Publishing
Charleston, South Carolina

Printed in the United States of America

Library of Congress Control Number: 2013945124

For all general information contact Arcadia Publishing at:
Telephone 843-853-2070
Fax 843-853-0044
E-mail sales@arcadiapublishing.com
For customer service and orders:
Toll-Free 1-888-313-2665

Visit us on the Internet at www.arcadiapublishing.com

*Dedicated to the people of Hightstown and East Windsor,
past, present, and future, and to the Hightstown–East
Windsor Historical Society. Without the assets of the historical
society's library, this book would not have been possible.*

CONTENTS

Acknowledgments

Unless otherwise noted, all images in this book are courtesy of the Hightstown–East Windsor Historical Society. In preparing to meet the requirements of compiling this book, the full magnitude of the historical society's postcard collection became apparent. The society's trust in letting go of the original postcards for nearly a year, enabling me to scan each front and back for the society's files, was a tremendous asset towards the completion of this book. Arcadia Publishing then needed to scan each selected postcard with highly specialized equipment, requiring the society to mail the postcards to the publisher and surrender control of the collection from October 2013 to April 2014.

Factual and interesting captions were needed for each postcard, but most of the postcards in the collection had few or no words to describe the image on the postcard. Fortunately, Robert and Kathy Patten (R&KP) generously stepped in to track down information about each postcard. In some cases, they met with former owners of the places depicted and learned about the images firsthand to provide more detail.

Additionally, all of the Peddie School captions came from Dr. David Martin (Dr. DM), a member of the Peddie School faculty and former Hightstown Borough historian. Without his knowledge and input regarding the Peddie School images, that section of chapter two would not have been possible.

Robert W. Craig (RWC), a life member and former library chairman of the Hightstown–East Windsor Historical Society, reviewed the final captions for accuracy. Without Bob's meticulous attention to detail, many of the captions would have contained lore rather than history.

Additionally, assistance provided to the Pattens by Kim Luke, Scott Perritt, and Mary Mastoris, and to the author by Hightstown Borough historian Charles (Cappy) Stults III (CS), Amos Lattimore, and Cookie Cummings (CC), is greatly appreciated.

INTRODUCTION

Historic preservation has played an increasingly important role in my life. It all began with the purchase of my 1885 Victorian Vernacular house in Hightstown 19 years ago, 110 years after it was constructed.

As a resident of Hightstown, its period of significance—1830 to 1915—has penetrated my soul. Having studied and obtained a degree in architecture during a particularly modern era under the tutelage of modernist professors, my more recent embrace of historic architecture is a radical departure. Being a resident of Hightstown has influenced me in many positive ways, including motivating me to earn a certificate in historic preservation from Drew University.

This book series was introduced to me in 2009 when I was looking for a publisher for my first book, *A Guide to the Architecture of Hightstown Houses* (available on Amazon or at www.stocktonstreetsolutions.com). After that book was published, Arcadia approached me to compile a book of historic postcards of Hightstown and East Windsor.

This book introduces readers to many buildings and places of Hightstown and East Windsor that either no longer exist or have been repurposed and renovated from their original form. As a town, we have always had some appreciation from whence we came; however, a comprehensive view of our period of significance has been spread across various archives and personal collections. This collection, assembled in one place, provides a fuller view than we have previously had of our community's evolution.

The contents of this book cover two towns that will forever be connected. East Windsor surrounds Hightstown in a way similar to a jelly donut, in which Hightstown is the tasty filling. East Windsor was originally part of New Windsor, dating back to the 1600s. By 1747, the eastern end of New Windsor already contained about two dozen farms. But the neighborhood was without a center and still relied on Cranbury, the nearest hamlet four miles away, with its mill, churches, and taverns.

On May 1, 1747, John Hight bought 80 acres on the north side of Rocky Brook, where the Old York Road, an important colonial thoroughfare in the region, crossed the stream. These features and a gradual fall in height were enough to create a battery pond that could drive mill machinery. Today, this pond is Peddie Lake and Old York Road is Main Street. To impound all of this water, Hight had to build a dam of considerable extent, possibly 500 feet long altogether. He finished the mill in 1749 and sold it to a newcomer from Hunterdon County.

The 80 acres was the only land that Hight owned, and he did not include much of it in the sale of the mill. The remaining land soon became crowded with buildings related to the mill. Within 15 years, the land included a "dwelling-house two stories high, a kitchen, and sundry

out-houses" (RWC). By 1773, there were also storehouses adjoining the mills, as well as a barn and stables. Hight kept the rest of his land and farmed it, planting an orchard on part of the property. While he had originally listed himself as a wheelwright, he later called himself a yeoman (a farmer and small property owner).

To increase his income, Hight opened his house as a tavern, the first at Rocky Brook. This house stood on the west side of the Old York Road, near where Hightstown Engine Company No. 1 now stands. Tavern owners in colonial New Jersey were important figures, and their status was frequently enhanced with law enforcement responsibilities. They were often appointed to serve as constables, especially in their first few years.

Without question, the early years from John Hight's arrival in 1747 through 1767 were the pinnacle of his career. He was the leading figure at Rocky Brook, and it was about this time that the growing village was referred to on a map as Hytes Town. The old term Rocky Brook no longer referred to the village, but only to the stream itself.

Through the decade, John and Mary Hight lived in the house where he ran his tavern. In May 1789, the Hights sold their house and last bits of land and disappeared from the historical record. Hightstown was formally incorporated in 1853.

According to *Rootsweb*, Hightstown owes its prominence to the construction of the Camden & Amboy Railroad, and it is doubtful without this impetus that it would have ever grown out of its status as a hamlet. The village had previously enjoyed the status of being on a stage route, but it was not until it acquired the dignity of a railroad town that it showed any marked promise of growth.

Prior to 1873, postcards did not exist. The only way that people could correspond with each other across the state, across the country, and across the globe was via handwritten letters. Friends and family had to write out more than "having a fine time." When writing letters to friends or loved ones, the writer had to describe in words what they had seen and the places they had been. There was no way to send others a picture of where they lived or had visited on vacation or business.

In 1873, the US government postal card came into existence. The Postal Service allowed a card with a message on one side and the address on the other side to be sent (not so interesting as to be included in this book since there was not a picture included, but an interesting fact nonetheless). The postage for these cards was 1¢. In 1898, private printers were allowed to publish cards with a picture on one side and the address on the other side. In the Hightstown–East Windsor Historical Society collection, there are several examples of postcards printed by local photographers and entrepreneurs. For instance, J.V. Davison, a local merchant, is listed on the back of some of the cards as "J.V. Davison Publishing." These cards were also mailed for 1¢ each.

The postcard format that we know today came about in 1907, when the Postal Service allowed the rear of the card to be split in two. This allowed a message of considerably more length than "wish you were here" to be included on the left and the addressee to be listed on the right. Along with cues from the images on the front of the cards, this information helps us to determine the time frame of the cards in the collection. Pieced together, they bring to life a past we might otherwise never have the means to witness.

After reading this book, I encourage readers to visit our quaint historic town. Shop, eat, stroll, and stay awhile. We have a lot to offer, both as a distraction and a lifestyle. While our train station has gone, we are situated well within a reasonable ride from Philadelphia, New York, and Princeton. Please come see us; we would love to see you and talk.

One

HIGHTSTOWN'S
HISTORIC HOUSES

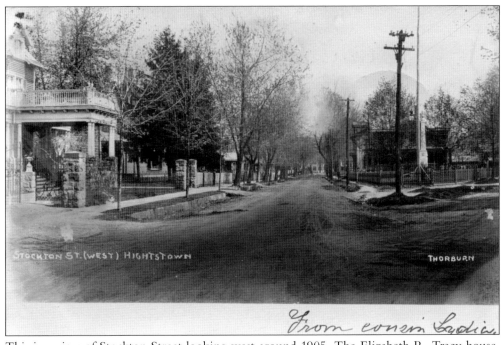

This is a view of Stockton Street looking west around 1905. The Elizabeth R. Tracy house, built in 1890, is on the left, and on the right is the Soldiers Monument, recently restored at the intersection of Rogers Avenue. In the 1800s, Stockton Street was known as "The Road to Princeton." It was renamed Stockton Street in honor of one of the signers of the Declaration of Independence, Richard Stockton. (R&KP)

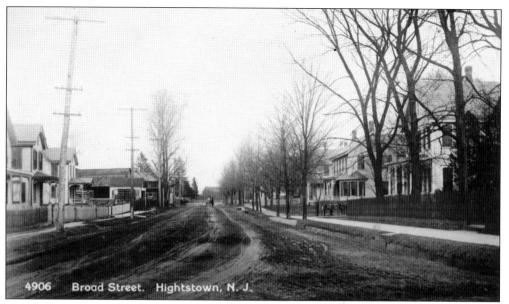

Broad Street, pictured here looking north around 1905, connects Franklin and Monmouth Streets. Originally named Corporal Street, it was renamed in 1883. Shangle & Hunt Lumber Company was midway down on the left. Broad and Monmouth Streets were to be part of State Highway Route 7 until Route 33 was built, which utilized Franklin Street. Route 33 then became the main thoroughfare from Trenton to Asbury Park. (R&KP)

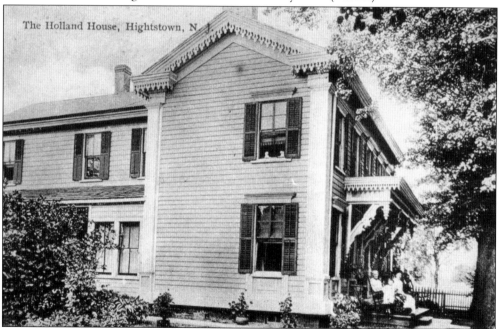

The Holland House, originally owned by Stephen Anderson, was built in 1829 as part of a large farm. In 1892, Michael Holland and his wife, Sarah Ward, purchased the house and farm. The Cranbury Manor housing development was built on part of the land, with Holland Lane being the entrance road, off Old Cranbury Road. The house still stands at 107 Old Cranbury Road, East Windsor Township. (R&KP)

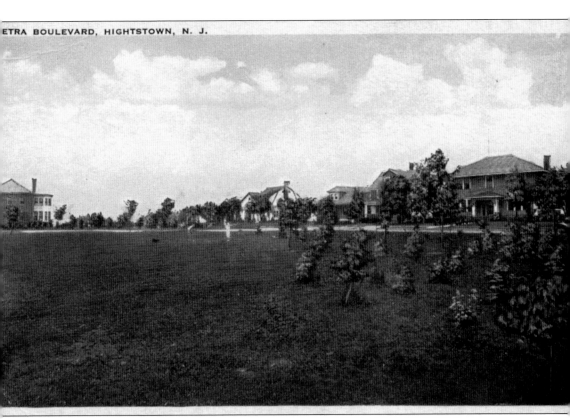

Etra Boulevard is now part of county road Route 571, which runs from Princeton to Toms River. In 1866, Etra Boulevard was opened by the state of New Jersey and was a new graded, gravel turnpike with tollgates and pikes operated by the Hightstown and Perrineville Turnpike Authority. This allowed Hightstown and Etra residents to travel easily between the two towns. A stone was placed every mile along the turnpike with the distance from Hightstown engraved on it, which explains the term "milestone." The turnpike led to Etra, a little village outside of Hightstown with a lake and park. Originally known as Scrabbletown, it grew into a thriving community after a gristmill was erected in 1781, followed by a sawmill and then several houses and businesses. By 1825, it had become the center of commerce in the area and was renamed Milford because of the importance of the mills located there. It was ultimately renamed Etra in honor of its most prominent citizen, Edward Taylor Riggs Applegate, who served as judge of the Court of Common Pleas in Mercer County. (R&KP)

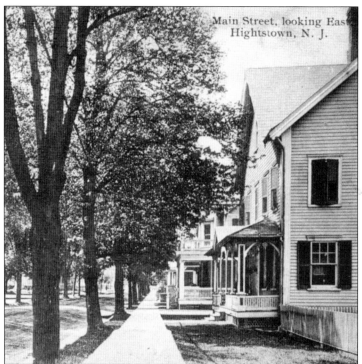

Main Street, looking East Hightstown, N. J.

In this image, the elements of mid- to late 19th century architecture can be observed in the mature street trees, closely spaced houses, shallow front yards, and front porches that allowed neighborly exchanges with passersby. Porches proliferated after 1840 due to the population's increase in leisure time. In the early 1900s, due to the noise and dirt of the automobile, socializing occurred inside and happenstance social exchanges dwindled. (R&KP)

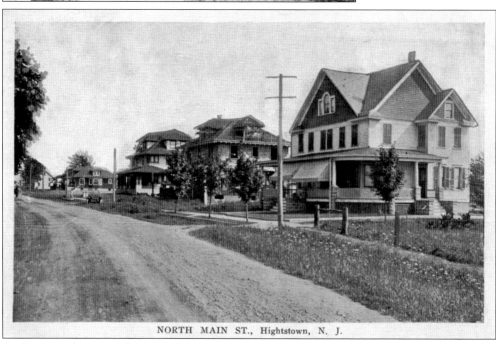

NORTH MAIN ST., Hightstown, N. J.

Looking north on North Main Street around 1920, the road remains unpaved. Homes ranged from late Victorian Vernacular to Prairie School styles, late 19th and early-20th-century styles. As the town grew, it expanded outward along major roads. North Main Street began at the corner of Stockton and Main Streets and eventually reached the town limits on the road to Cranbury by the 1920s. (R&KP)

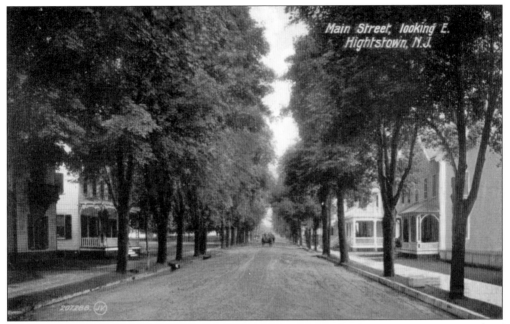

Main Street was part of an Indian trail used by settlers, with New Amsterdam on the north of the colony and William Penn's town to the south. It was named the Duke of York Road after the royal Duke of York, who gave the British colony Nova Caesarea, or New Jersey, to Sir George Carteret and Lord Berkeley in 1664. (R&KP)

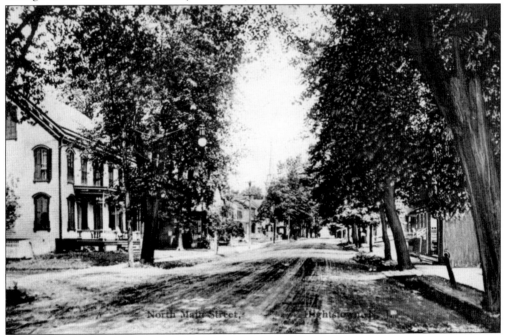

This Greek Revival–style home, built around 1880, is close to the street and shaded by mature trees. Most homes built in the mid- to late 19th century were of traditional architectural styles, closely spaced, and had shallow front yards. The church, erected in 1857, is within easy walking distance, completing a picturesque neighborhood. This postcard is dated 1914. (R&KP)

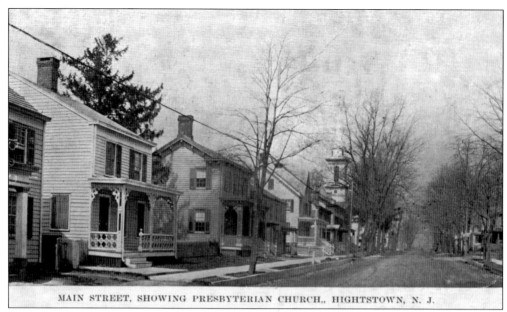

MAIN STREET, SHOWING PRESBYTERIAN CHURCH,, HIGHTSTOWN, N. J.

The Victorian and Colonial-style houses shown here are still inhabited as of 2014. Decorative gingerbread elaboration beautifies the front porches, which were probably added in the 1880s. With industrialization and the railroad came the ability to obtain pre-manufactured decorative woodwork. Mail-order catalogs proliferated, opening the country to buyers beyond businesses' locales. The First Presbyterian Church can be seen in the distance. (RHP)

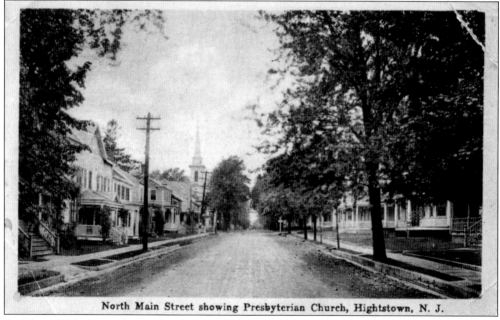

North Main Street showing Presbyterian Church, Hightstown, N. J.

In this c. 1910 postcard, there is a noticeable absence of trees near the utility poles on the left curb. The Electric Light and Power Company of Hightstown was supplying North Main Street with electricity to light homes and power new washer machines. Concrete sidewalks and curbs are also visible. Hightstown had moved into the modern era. In 1923, Hightstown installed poles and strung electric wires through East Windsor. (R&KP)

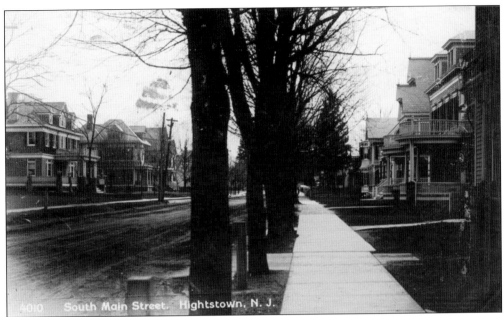

Queen Anne–style homes dominate this residential block. They were built between 1880 and 1910 and featured elaborate shingle patterns and handsome bay windows and turrets with sparkling, stained glass windows. Today, all can be observed in a pleasurable walk back in time up and down South Main Street. (R&KP)

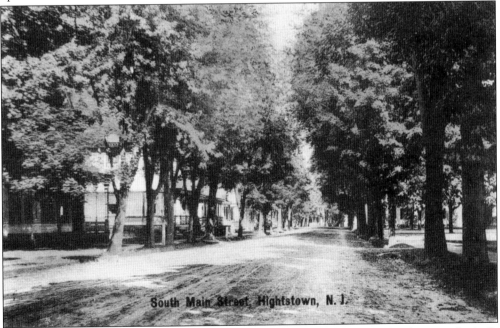

According to the February 10, 1876, issue of the *Hightstown Gazette*, the first house to be built "out of town" was occupied by J.C. Ward: "Now both sides of the thoroughfare are thickly studded with buildings, Peddie Institute taking the lead. It is rather an aristocratic quarter too, for at this end of the town are settled a number of retired farmers, and at least one printer-banker." (R&KP)

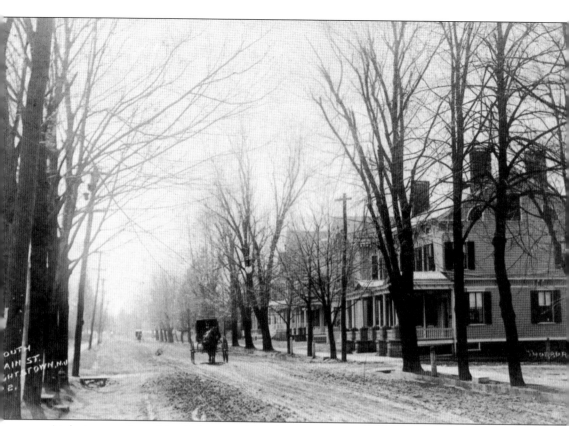

At the intersection of South Street and South Main Street is the home and office of Dr. George H. Franklin, a family physician in the Hightstown area for 46 years. Franklin Street was named after this longtime community servant. In 1890, Dr. Franklin made extensive improvements to his property, adding a large windmill in the backyard to generate electricity and to pump well water. This photograph was taken around 1900, after electricity was provided to the town and the removal of his windmill. Dr. Franklin not only served his community but the country as well. On the evening of November 2, 1912, a limousine carrying Gov. Woodrow Wilson drove into Hightstown on its way to Princeton. At the intersection of Monmouth and North Main Streets, it struck a bump, and Wilson was injured with a deep cut to his scalp. Wilson was treated by Dr. George Titus, who lived on South Main Street, and was assisted by his neighbor Dr. George Franklin. The patient was elected president three days later, none the worse for wear for having traveled through Hightstown. (R&KP)

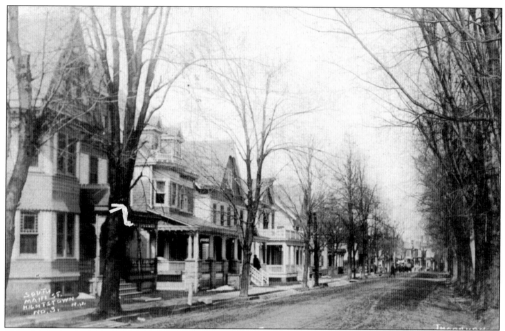

Queen Anne–style homes fill the west side of South Main Street facing the Peddie School. The John V.D. Beekman house, closest on the left, was built in 1887 and exemplifies Queen Anne–style architecture. Beekman owned a planing and molding mill on West Ward Street in the late 1800s. His mill supplied much of the woodwork for the homes in Hightstown. (R&KP)

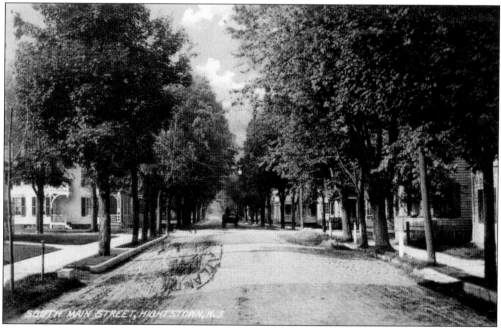

This is South Main Street at the corner of South Street. Although automobiles had arrived on the scene in 1906, carriage steps with the owner's name inscribed remained in front of homes. The stone carriage steps still stand, waiting to assist travelers into carriages. The inscription on this stone is "Franklin," denoting the residence and office of Dr. George H. Franklin. (R&KP)

SOUTH MAIN ST., Hightstown, N. J.

This Foursquare-form house was built in 1912 for local druggist Milton H. Cunningham Sr. It is built in the Craftsman style. The home beyond the trees is the Applegate House, designed in 1901 by George Franklin Barber and built in 1905. It is a Colonial Revival–style house with a two-story, classic columned front porch and two side one-story hexagonal porches. (R&KP)

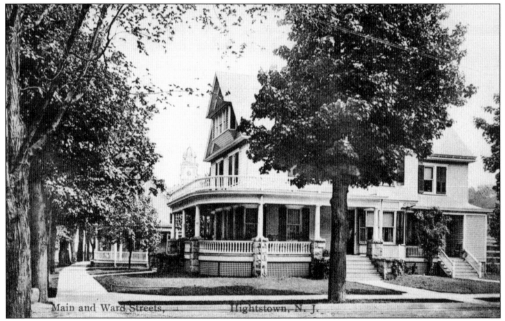

Main and Ward Streets, Hightstown, N. J.

Located at the corner of East Ward and South Main Streets, this house was built shortly after 1901. Known as the Priory House, it was occupied at times by a law firm and family services agency. In 2010, the house was purchased by the Peddie School and completely renovated in 2012. (R&KP)

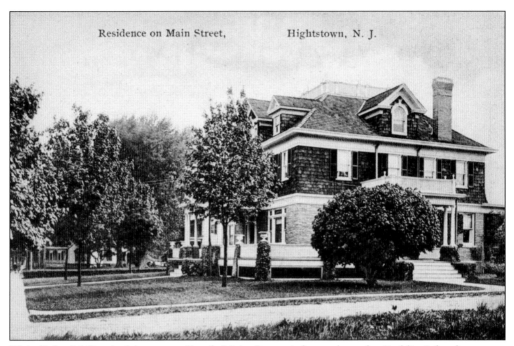

Residence on Main Street, Hightstown, N. J.

This Colonial Revival home on South Main Street is located on the Peddie School campus. It was used as the home of the head of school, or headmaster, until 2013. It was no doubt the scene of many Peddie School social gatherings. Its spacious living space and side porch provided a beautiful setting for the head of school and his family. (R&KP)

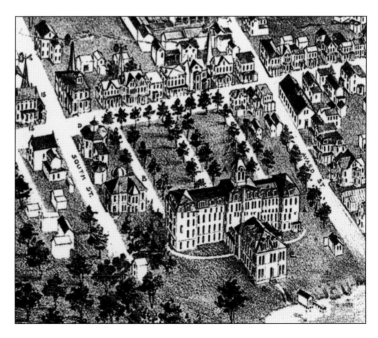

A portion of the 1895 poster reprint available from the Hightstown–East Windsor Historical Society is pictured here. From 1884 to 1901, the site of the Priory House (pictured on opposite page) was home to the Hightstown Roller Skating Rink, visible here at upper right. The rink was torn down in 1901. Also visible here is the Octagon House and Wilson Hall on the Peddie School campus (see pages 21 and 32). (RHP)

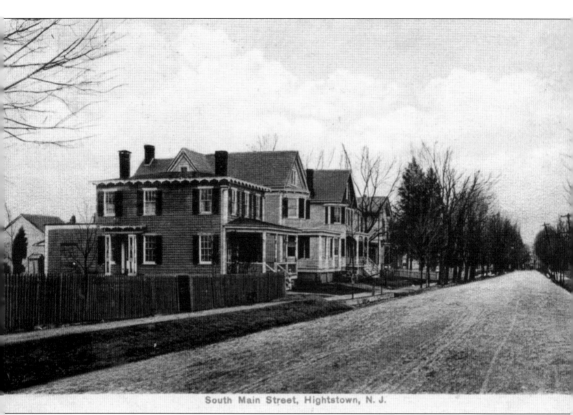

South Main Street, Hightstown, N. J.

The house on the left, which is no longer there, is an Italianate. Its flat roof, decorative trim, three front windows, and simple hipped roof are identifying characteristics of this style of architecture. Italianate houses were built between 1840 and 1880. The style was popularized by the influential pattern books of Andrew Jackson Downing published in the 1840s and 1850s. By the 1860s, the style had completely overshadowed its earlier companion, Carpenter Gothic. The decline of the Italianate style, along with that of the closely related Second Empire style, began with the financial panic of 1873 and the subsequent depression. This home was built during Hightstown's prosperous era, when farmers and businessmen located their families along South Main Street, which was considered one of the most fashionable parts of town. Its proximity to the Peddie Institute added to its charm. The rooflines of Victorian-era homes built later continued the extension of this lovely tree-lined street.

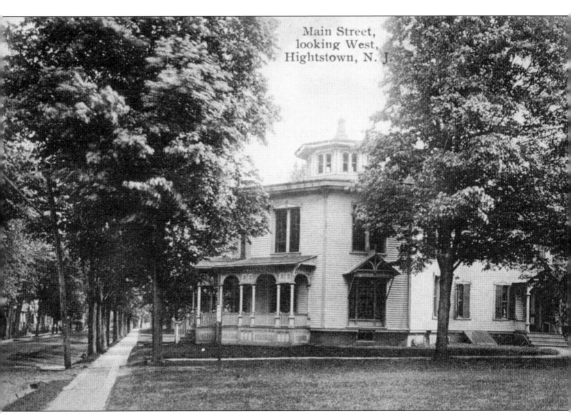

Main Street,
looking West,
Hightstown, N. J.

This South Main Street house, known as the Octagon House, was built in 1857 by Dr. Calvin Bartholomew, a homeopathic physician. The eight-sided house was considered healthier since it allowed sunlight to shine in at every hour of the day. However, the Hightstown Octagon House had a dark side, too. According to local lore, Caroline S. Hutchinson purchased the home in 1888 and remodeled it by covering it with clapboards and adding an addition to the rear. She died in the house in 1892, and after her death, her jewelry, including $3,000 worth of diamonds, was missing and never found. This mystery and the occasional sighting of a ghost led to the commonly held belief that the house was haunted. The house was given to the Peddie School in 1896. Still owned by the school, it now has two apartments occupied by Peddie staff. (R&KP)

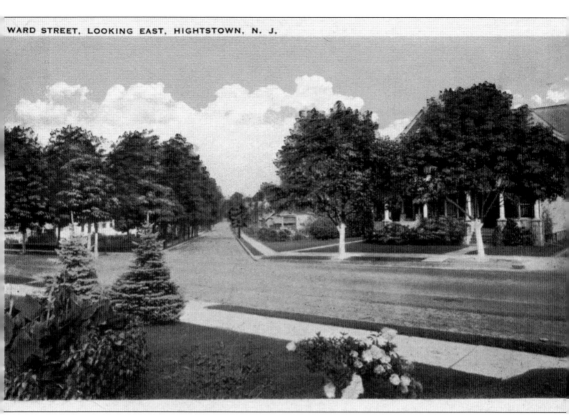

This view is actually the corner of Mercer and South Streets, looking east. The house on the right is 301 Mercer Street. In 1900, except for a few houses, South Street between South Main and Mercer Streets was undeveloped. A brook called Grape Run ran across it, creating a marsh that was used as a town dump and an open sewer. Calls for cleaning up South Street were finally answered when the town voted to install a new municipal water system in 1896 and a municipal sewer system in the early 1900s. At this time, Grape Run became an underground piped stream leading to Rocky Brook on the west side of North Main Street, behind the businesses. It can be accessed from the basement of 110 Mercer Street to this day. South Street was now open for development, and between 1900 and 1940, a series of Foursquares and Craftsman-style homes were built on this lovely street. Taylor Avenue and Pershing Avenue were later created to provide more residences off of South Street. (R&KP)

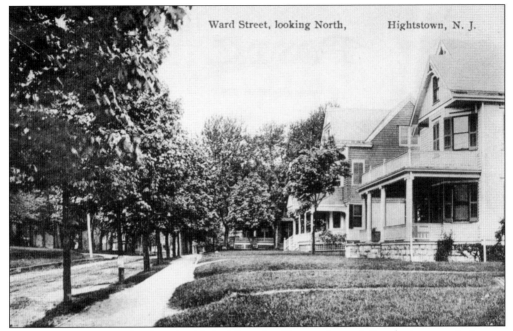

East Ward Street was developed with its Victorian Vernacular and Queen Anne–style houses opposite the Peddie School campus. Ward Street was named for the Onn Ward family, who owned a large part of early Hightstown. The Peddie School and the Mercer Street School (now the YMCA) were built on land that was donated by the Ward family. (R&KP)

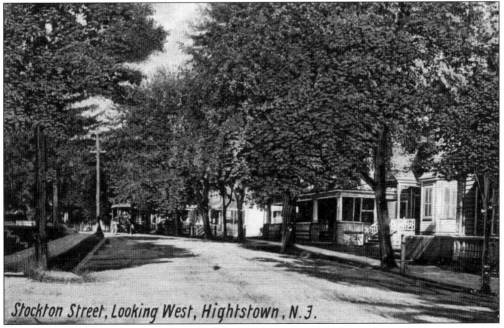

Stockton Street, Looking West, Hightstown, N.J.

On the right is the John B. Polhemus House, located in the Stockton Street Historic District. It is a Queen Anne–style home and was built in 1889. The owner, John Polhemus, was a foreman for the railroad and had his home built on the same street as the Hightstown depot. The second house on the right is shown at the top of page 25. (R&KP)

23

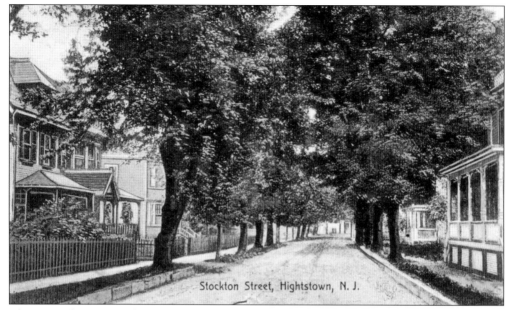

Stockton Street, Hightstown, N. J.

This is Stockton Street looking east in 1910. This section of the street is part of the Stockton Street Historic District. The homes are from the late Victorian era and were built during Hightstown's period of significance beginning with the establishment of the Camden & Amboy Railroad in 1832. The street expanded in a westward direction as homes were built to accommodate the growing population of merchants and families of means. (R&KP)

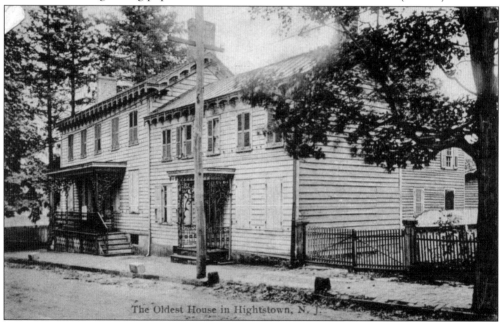

The Oldest House in Hightstown, N. J.

Thought to be the oldest house in Hightstown, the Smith House was built between 1770 and 1785 by Enos Baldwin. In 1803, it served as both a dwelling and a store, which was operated by Baldwin. In 1819, it was used as a post office with Robert Purdy as the postmaster. It was purchased by Rescarrick Moore Smith in 1852 and remained in the Smith family until 1944. (R&KP)

This Colonial Revival house on Stockton Street is still standing; however, it is hard to find, as the entire porch is gone. The ashlar stone base, columns, and roof have all been removed. The main volume of the house still shines through with the frieze detail at the eaves and window placement (see the top of page 117 for a view of the house today).

Labeled as "Stockton Street, looking north," this view is actually looking west. Expansive front porches and wide sidewalks were characteristic of these Victorian Vernacular and Queen Anne homes, which were mostly built between 1880 and 1920. Their inviting wraparound porches were indicative of the walking culture that existed at the time, when neighbors visited and exchanged pleasantries with one another. (R&KP)

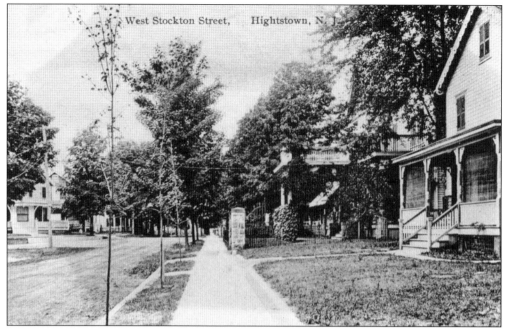

Stockton Street sidewalks connect homes along the street across from the Soldiers Monument at the intersection of Rogers and Stockton Streets. Newly planted trees suggest the efforts made to keep this street beautiful. The house on the right is a Victorian Vernacular with decorative turned spindle work on its porch. (R&KP)

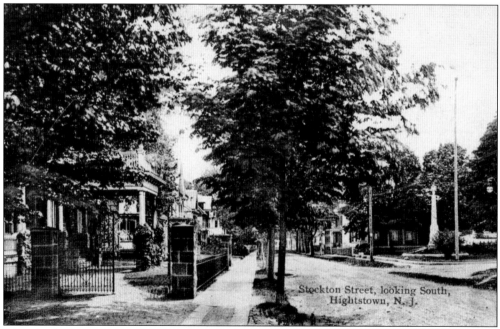

The Elizabeth R. Tracy House was built around 1890 and was designed with a porte cochere, a covered entrance sheltering those arriving in carriages. It is one of the distinctive features of this very well preserved, grand old Queen Anne–style house, which is located on the corner of Stockton Street and Park Way. (R&KP)

Two

Past Schools in Hightstown and East Windsor

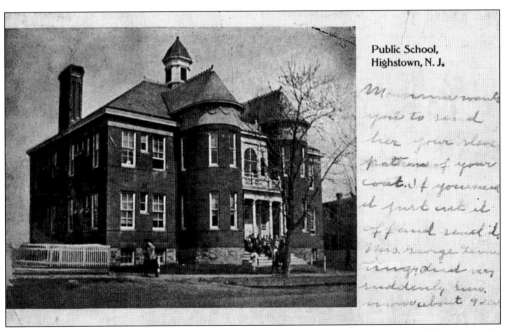

Public School,
Highstown, N. J.

Having replaced the Academy, the Mercer Street School was the second public school in Hightstown. It served kindergarten through 10th grade and opened on January 7, 1895. Built for the grand sum of $12,000, it was considered a state-of-the-art school. A handsome brick building with stone trimmings and a high-pitched slate roof, it was an impressive school for a small town like Hightstown. (R&KP)

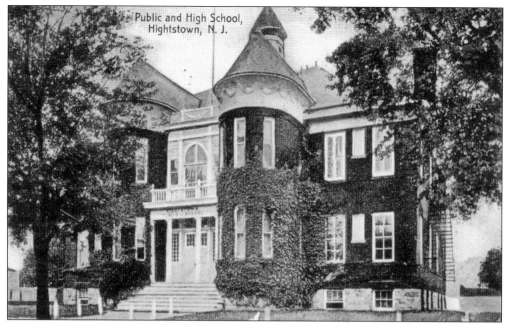

The Mercer Street School was built on the same land that the Academy had occupied from 1841 to 1894. It had turrets, a Palladian window, and a belfry that housed a large bell originally used in the Academy (see page 126). Students arrived by horse-pulled carriages that had 12 seats in two rows. The school originally only had outdoor toilets, but boys' and girls' toilet rooms were later constructed in the basement. (R&KP)

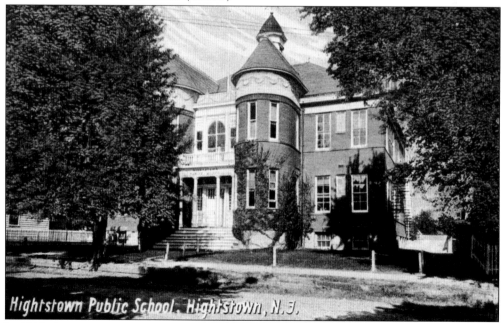

In 1915, there was an expansion of the town when residents voted to extend the town's limits to nearly the present boundaries. Also, the one-room schoolhouses on Cedarville Road, Etra Road, Hickory Corner Road, and at Locust Corner were closed, and these students were transported to the Mercer Street School and the new high school on Stockton Street. (R&KP)

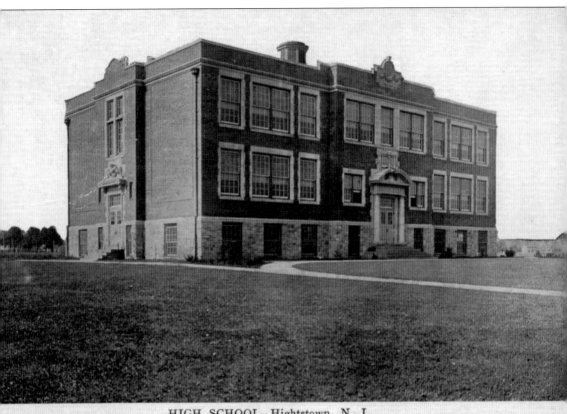

HIGH SCHOOL, Hightstown, N. J.

The first Hightstown High School opened on the south side of Stockton Street on September 8, 1913. Up until this time, students in Hightstown had gone to school through the 10th grade and then completed their studies in Trenton. The exterior of the new high school was constructed of brick with terra–cotta trimming. There were five classrooms on the first floor for grammar school grades, a library and teachers' room, and a supervising principal's office. On the second floor were four classrooms for the high school and a science laboratory with a lecture room adjoining it. A cafeteria was in the basement. There were separate entrances for the boys and the girls. In 1925, a new high school was built across the street for grades nine through twelve, and the old high school changed its name to the Stockton Street Grammar School for kindergarten to grade eight. It was demolished in 1967. (R&KP)

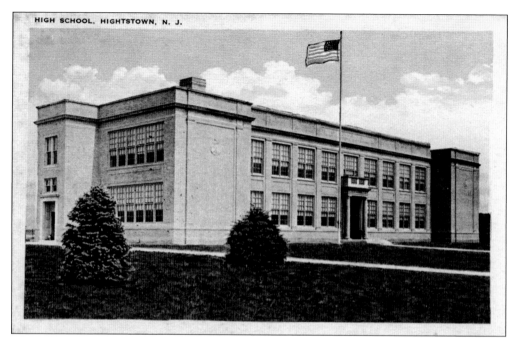

The second Hightstown High School opened on January 12, 1925. Only 11 years after the establishment of the first Hightstown High School, it became necessary to build a new school because of the growth of the community and the state mandate of compulsory education. The new school was built on a portion of the Job farm on the north side of Stockton Street, across the street from the first high school. (R&KP)

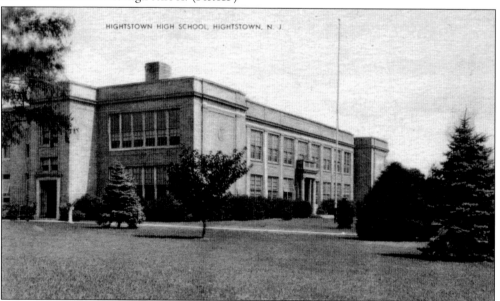

HIGHTSTOWN HIGH SCHOOL, HIGHTSTOWN, N. J.

The new high school was well equipped with spacious classrooms, an auditorium, administrative offices, and a large athletic field. Again, the girls and boys had separate entrances. In 1937, the auditorium was enlarged, eight more classrooms were added, and a gymnasium with separate locker rooms for boys and girls and a library were constructed. In 1949, the boys' industrial arts shop was added. (R&KP)

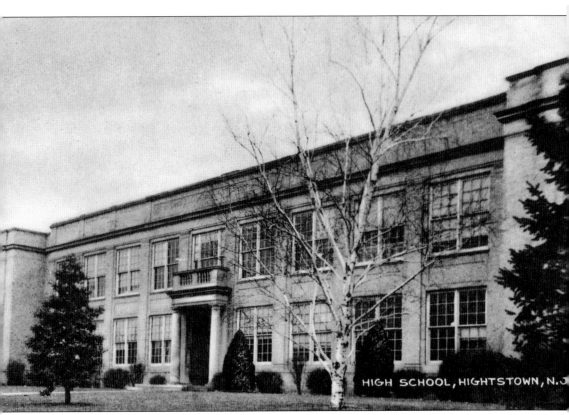

HIGH SCHOOL, HIGHTSTOWN, N.J

Hightstown High School served as a high school from January 1925 to February 1966, when the current high school located off Leshin Lane was opened. During the 1950s, Hightstown and East Windsor continued to grow with the opening of the New Jersey Turnpike. As large cities were brought closer, industries and large companies relocated in this area. It became an attractive place to live as new housing developments were built both in Hightstown and East Windsor. Schools needed to expand to accommodate the increasing number of children. The Walter C. Black Elementary School was built in 1950. Both it and the high school were expanded later in the decade. In 1966, the Stockton Street high school building became the Grace Norton Rogers Middle School (grades six, seven, and eight); it is currently the Grace Norton Rogers Elementary School for kindergarten to grade five. (R&KP)

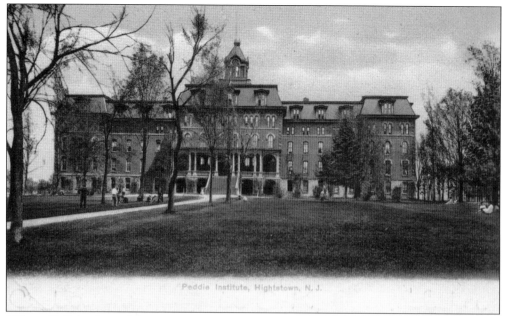

Wilson Hall is pictured here around 1900. Peddie was founded in 1864 as the New Jersey Classical Institute, and was renamed the New Jersey Classical and Scientific Institute a year later. In 1872, the school's name was changed to the Peddie Institute in honor of an early benefactor, Thomas B. Peddie (1808–1889), a businessman and philanthropist from Newark. A final name change to the Peddie School was made in 1923. (Dr. DM)

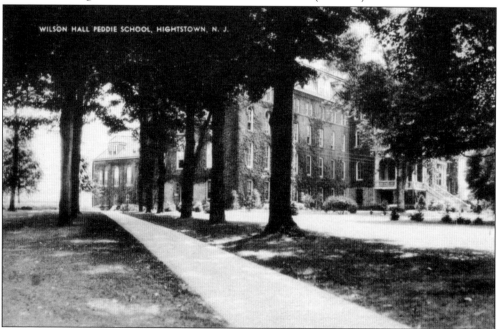

Wilson Hall was 255 feet long and five stories tall. It had 84 rooms for classrooms, with girls assigned to the south wing and boys to the north wing. Until 1884, only the girls had indoor plumbing. The dining room was in the center of the building on the first floor, and the chapel was on the second floor. At the end of the tree line is the dining hall, which was constructed in 1895. (Dr. DM)

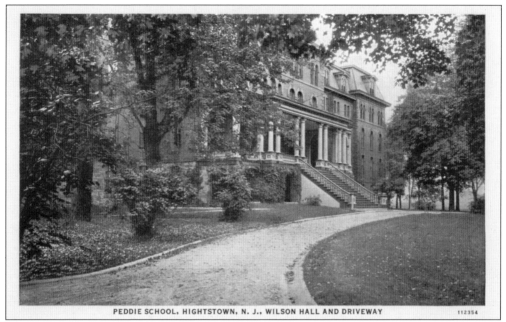

PEDDIE SCHOOL, HIGHTSTOWN, N. J., WILSON HALL AND DRIVEWAY 112354

The Peddie School had no buildings of its own when it was founded in 1864 and held classes in the Sunday school wing of Hightstown Baptist Church. Land adjacent to what is now called Peddie Lake was purchased from the Ward family in 1865, and construction of a large school building commenced in 1866. The building was named in honor of Rev. William V. Wilson in 1905. (Dr. DM)

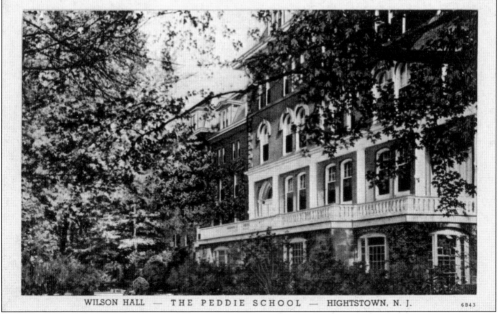

WILSON HALL — THE PEDDIE SCHOOL — HIGHTSTOWN, N. J. 6843

Wilson Hall was originally dedicated on October 26, 1869. This c. 1930 view shows a later renovation of the large front porch. Beneath the porch was a smoking lounge, and the basement housed a shooting range, bowling alley, and batting cages. There was a gymnasium on the fifth floor. (Dr. DM)

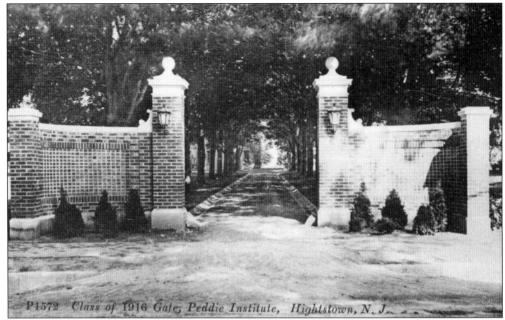

P1572 Class of 1916 Gate, Peddie Institute, Hightstown, N. J.

Wilson Hall was set back about 100 yards from Main Street and had two impressive tree-lined drives approaching it. The class of 1916 gates were erected at the southern entrance from Main Street and also gave access, on the right, to Longstreet Library. A companion set of north gates was constructed at the foot of the adjacent drive by the class of 1917. Both gates are still standing. (Dr. DM)

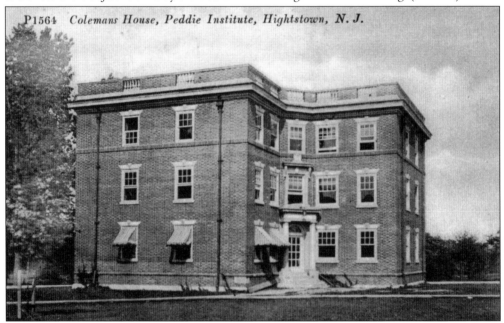

P1564 Colemans House, Peddie Institute, Hightstown, N. J.

Coleman House, built in 1912, was the first of three modern fireproof dormitories constructed as part of Headmaster Roger W. Swetland's plan for a "Greater Peddie." The building, still standing largely unchanged, was named in honor of Henry U. Coleman, a member of the board of trustees for 18 years and acting president for three years. A modern wing for an additional faculty apartment was added in 1966. (Dr. DM)

34

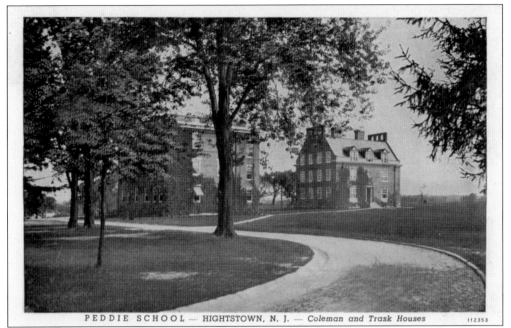

PEDDIE SCHOOL — HIGHTSTOWN, N. J. — *Coleman and Trask Houses* 112353

This image depicts Coleman House on the left and Trask House, built in 1914, on the right. Trask House consisted of three-room suites with a suite for the dormitory master. It was named after Dr. H.K. Trask, the last principal of the South Jersey Institute in Bridgeton, New Jersey, which was a rival Baptist school absorbed by the Peddie School Institute. The Trask House is still standing today, with a modern wing added in 1966. (Dr. DM)

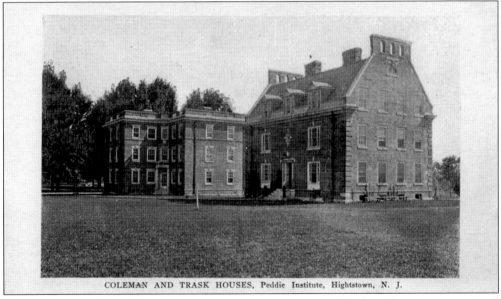

COLEMAN AND TRASK HOUSES, Peddie Institute, Hightstown, N. J.

Originally, all students in the school were housed in Wilson Hall. These dormitories consisted of three-room suites for every two boys, each boy having his own bedroom and sharing a common study room. Each study room had a fireplace with the letters "PI" (for Peddie Institute) in the tile above the fireplace. There was also a suite for a dormitory master on the first floor. (Dr. DM)

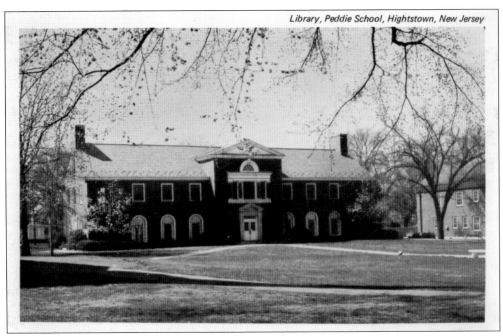

Ambassador Walter H. Annenberg, class of 1927, constructed Annenberg Library in 1957. It served as the school's library until 1993, when a new library was built on the back of Annenberg Hall. The Annenberg Library was renovated to house the alumni and development department and other offices. It was renamed Coates–Coleman House in honor of two former trustees, Henry G.P. Coates and Clarence Coleman, both from the class of 1928. (Dr. DM)

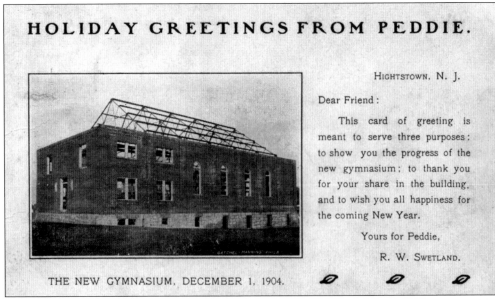

HOLIDAY GREETINGS FROM PEDDIE.

Hightstown, N. J.

Dear Friend :

This card of greeting is meant to serve three purposes: to show you the progress of the new gymnasium; to thank you for your share in the building, and to wish you all happiness for the coming New Year.

Yours for Peddie,

R. W. Swetland.

THE NEW GYMNASIUM, DECEMBER 1, 1904.

Peddie Institute's first athletic facility was not a building, but some training rooms on the fifth floor of Wilson Hall. The construction of a new gymnasium building at the extreme north end of campus was delayed by a windstorm that tore the incomplete roof off. This postcard, dated 1904, shows the rebuilding process, and, as noted, thanks donors for their additional contributions to finish the project. (Dr. DM)

This close-up image of the front porch of Alumni Gymnasium on the Peddie School campus dates to around 1930. It is possible that this is an earlier image than the one below, due to the lattice screens under the porch perimeter that are in disrepair. They may have been removed for maintenance reasons. The balcony was torn down by the 1950s. (RHP)

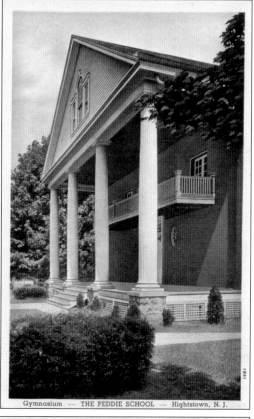

Gymnasium — THE PEDDIE SCHOOL — Hightstown, N.J.

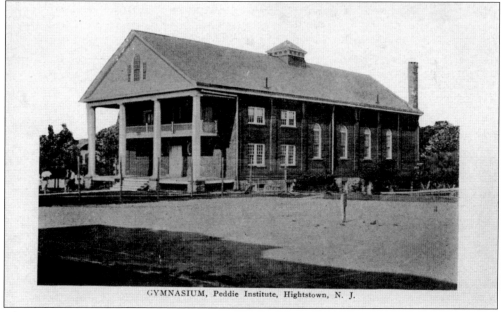

GYMNASIUM, Peddie Institute, Hightstown, N. J.

The new gym was completed in 1904. It featured a basketball court, a running track suspended from the ceiling, a primitive locker room, and a small pool. The cupola on the roof no longer exists, nor does the chimney at the back of the building. (Dr. DM)

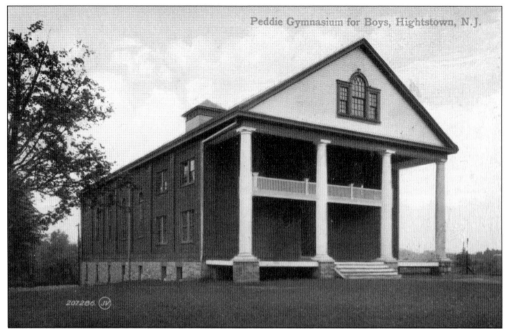

The Alumni Gymnasium was gutted and turned into a theater and speech and drama center in 1960, following the construction of the new Mills Memorial Gymnasium in 1948–1949. It was renamed Geiger-Reeves Hall in honor of Carl E. Geiger, English teacher, administrator, and archivist from 1918 to 1983, and J. Walter Reeves, public speaking teacher from 1912 to 1953. (Dr. DM)

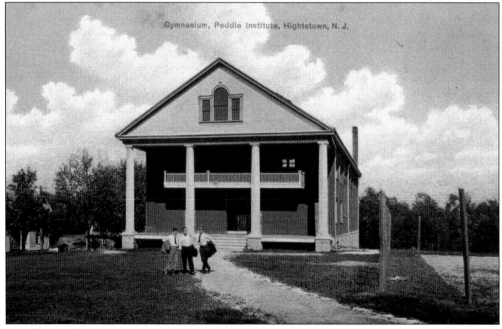

The front of Alumni Gymnasium at the Peddie Institute was rebuilt in 1988, when large Egyptian style columns were erected in the front and the porch was turned into a lobby. Peddie Lake is immediately behind the building, and the East Ward Street Bridge is behind the trees on the left. (Dr. DM)

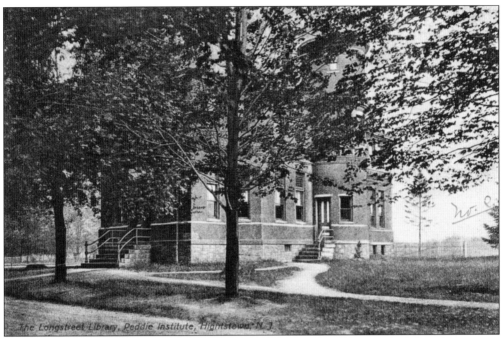

Longstreet Library was donated by Jonathan and Mary Longstreet of Holmdel, New Jersey, in 1889. It housed the school library downstairs and had science classrooms and laboratories upstairs. There is also a small observatory accessed by the stairway on the right. This beautiful building is well preserved and worth a visit. (Dr. DM)

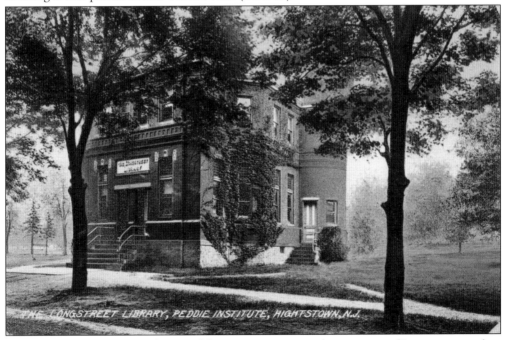

The Longstreet Library is to the east of the Octagon House and was converted into use as a student center in 1958, following construction of the new Annenberg Library in 1957. It later served as an art center and is currently a meeting hall with faculty apartments upstairs. (Dr. DM)

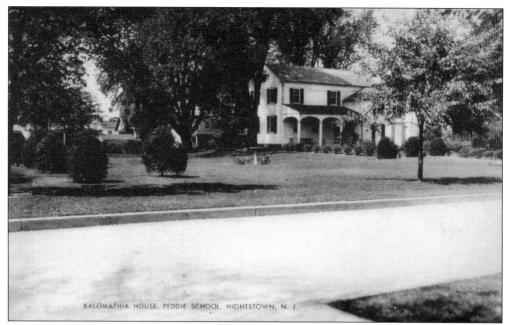

KALOMATHIA HOUSE, PEDDIE SCHOOL, HIGHTSTOWN, N. J.

Kalomathia House was acquired by the Peddie Institute in 1898 and was called Buchanan Cottage. It was used as a dormitory for lower school students until the construction of Austen Colgate Hall in 1928, when it was renovated for use as a guesthouse by the Kalomathia Society, a ladies literary society at the school from 1867 to 1908. This postcard is dated 1944 and shows a rear view of Kalomathia House. (Dr. DM)

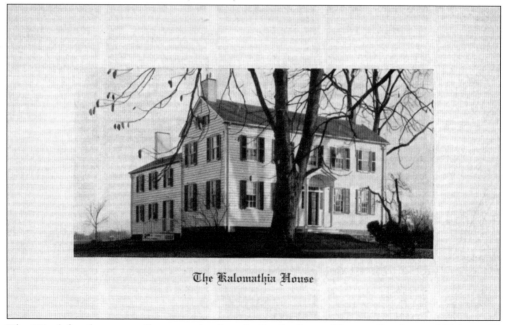

The Kalomathia House

The Ward family reportedly entertained such dignitaries as Horace Greeley and Phineas T. Barnum in Kalomathia House during the mid-1800s. John Ward sold eight acres of his farm to the school in the spring of 1865 for $8,000. The school later purchased the entire Ward farm in stages, and it now embraces some 280 acres. (Dr. DM)

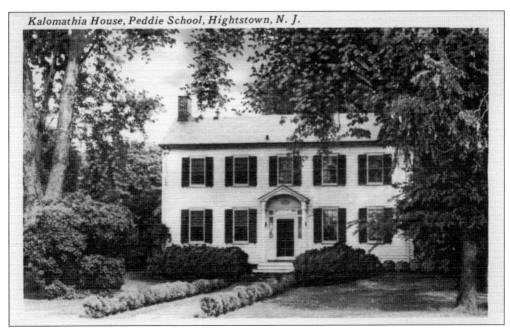
Kalomathia House, Peddie School, Hightstown, N. J.

Kalomathia House is presently used as a faculty residence. The house was built largely in the Georgian style, exemplified by a simple two-story rectangle form that is two rooms deep. The exterior shows a centered paneled door, a row of small windows above the door, and windows organized five across the front and symmetrically aligned left to right and top to bottom. It has not been renovated much since the 1930s. (Dr. DM)

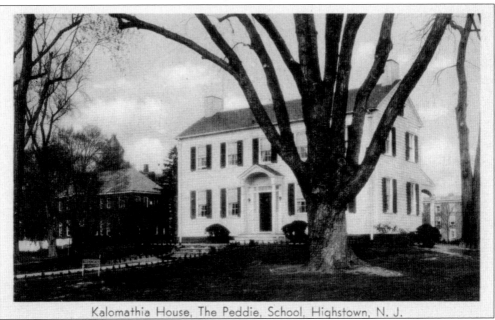
Kalomathia House, The Peddie, School, Highstown, N. J.

Kalomathia House is the oldest building on the Peddie School campus and one of the oldest surviving structures in Hightstown. John Ward constructed it in 1832 to replace an earlier house that burned down. It is on Main Street, south of Longstreet Library and north of Swetland House—the headmaster's residence from 1943 to 2013. (Dr. DM)

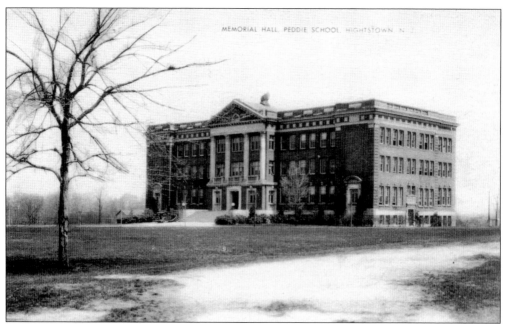

Pictured around 1930, Memorial Hall was built as the school's principal classroom and administrative building in 1923. The initial donation for the project was made by Horace Swetland, a cousin of Dr. Roger W. Swetland, the school's longest serving headmaster (1898–1934). Memorial Hall was named in honor of Peddie's 502 men who served in World War I, of whom 16 lost their lives. (Dr. DM)

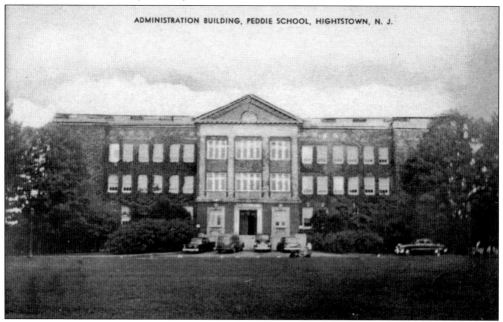

This is a later view of Memorial Hall from about 1940. During World War II, there was an aircraft spotting station on the roof. In 1992, the building was renamed Annenberg Hall in honor of Ambassador Walter H. Annenberg, the school's greatest benefactor, who donated $100 million to the school in 1993. (Dr. DM)

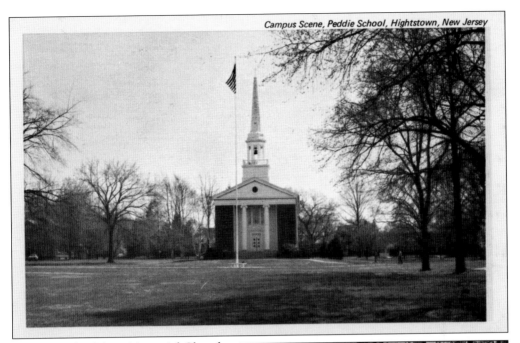

The F. Wayland Ayer Memorial Chapel on the Peddie School campus is shown from the middle of the campus green (without the side colonnades that exist today) around 1960. The F. Wayland Ayer Memorial Chapel was erected in 1949 at the southern end of the campus green to serve as the focal point of the central campus. It was dedicated in 1951. From 1869 to 1951, chapel was held on the second floor of Wilson Hall. (Dr. DM)

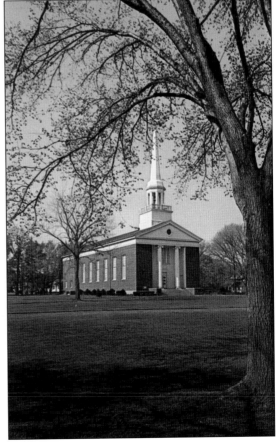

This is a view of the F. Wayland Ayer Memorial Chapel on the Peddie School campus from about 1970. Peddie School was founded as a Baptist school in 1864, and for many years, its headmasters were Baptist preachers. Baptist influence began to decline in the mid-1900s and was largely gone by the 1970s. It is now a nondenominational school, but chapel meetings are still held twice a week. (Dr. DM)

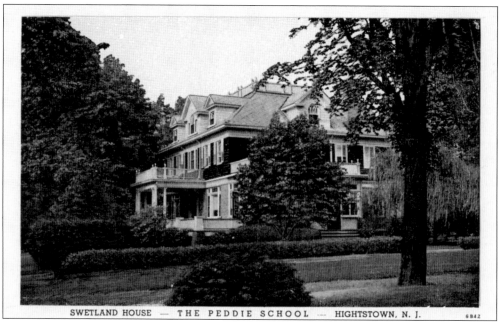

SWETLAND HOUSE — THE PEDDIE SCHOOL — HIGHTSTOWN, N. J. 6842

Swetland House, pictured here around 1950, was constructed around 1910. It was acquired by the school from the Chamberlin family to replace Octagon House as the headmaster's residence in 1942. It was named after Dr. Roger W. Swetland, the school's longest-serving headmaster (1898–1934) and served as the headmaster's residence until 2013. (Dr. DM)

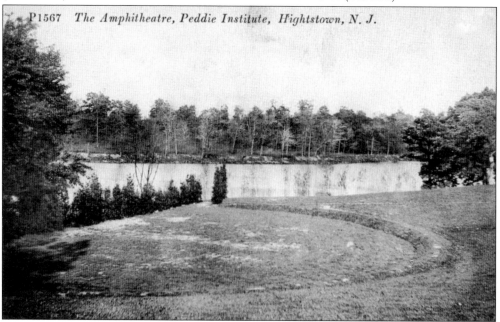

P1567 *The Amphitheatre, Peddie Institute, Hightstown, N. J.*

The outdoor amphitheater on the Peddie School Campus is pictured around 1930. The amphitheater was set up on a hillside adjacent to Peddie Lake, and its natural slope was used as a Greek theater for outdoor plays and concerts. In 1916, it was the scene of an extravagant pageant held to celebrate the school's 50th anniversary. A new student center was built over the site in 1995. (Dr. DM)

Three

TRAINS AND BRIDGES

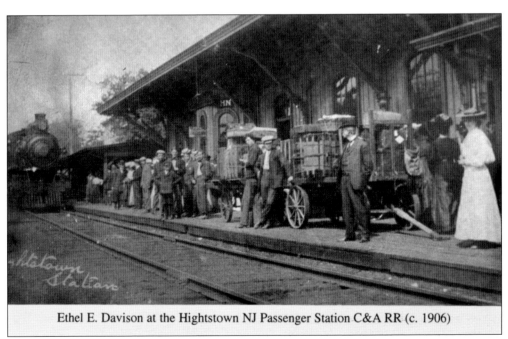

Ethel E. Davison at the Hightstown NJ Passenger Station C&A RR (c. 1906)

Ethel Davison (Hutchinson) is standing at the Hightstown passenger depot around 1906. She had just graduated and was waiting for the train to take her to a celebration. The gentleman with the derby was Mr. Perrine. They were part of a sizable crowd waiting for the train. The railroad depot was a busy center of activity, with people and merchandise on the move. (R&KP)

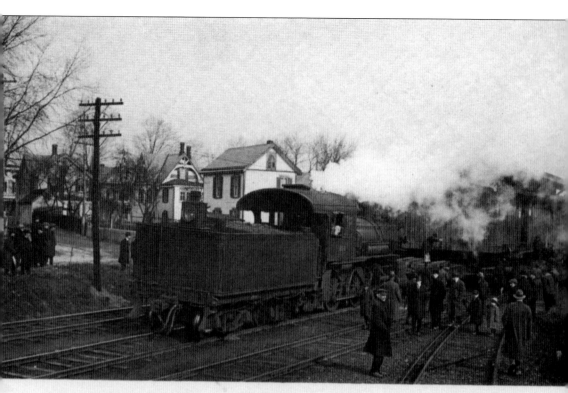

Moving the Old Hightstown Freight Station Summit & Mercer Strs. (1917)

The Camden & Amboy Railroad built a freight station in Hightstown in 1869. Due to increased traffic from outlying farms and local industry, the freight station was moved in 1917 to the southern corner of Mercer and Summit Streets. The station was moved one more time in 1990 to its present site behind the historical society's Ely House on North Main Street. The building has been renovated to house the Hightstown–East Windsor Historical Society's library and the Sara Hutchinson West Educational Center. The freight station now serves as a museum for train and agricultural items from the past, as well as the library. (R&KP)

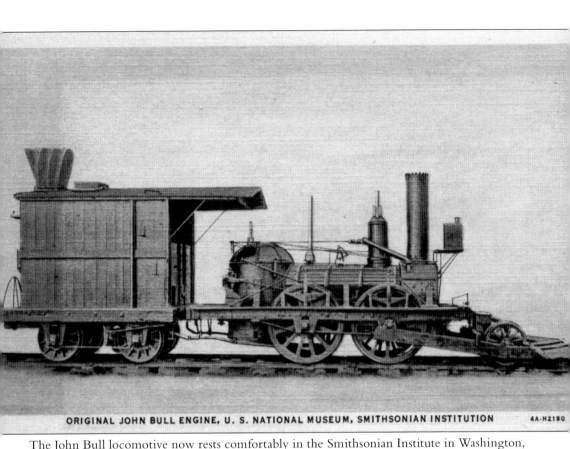

ORIGINAL JOHN BULL ENGINE, U. S. NATIONAL MUSEUM, SMITHSONIAN INSTITUTION 4A-H2180

The John Bull locomotive now rests comfortably in the Smithsonian Institute in Washington, DC, as the oldest still-operable locomotive in the United States. It was brought into service on the Camden & Amboy Railroad in 1833, when service was begun between Bordentown and Hightstown. The C&A soon became the first railroad in the nation to connect major cities—New York and Philadelphia. The railroad line was completed first to South Amboy in 1833, then to Camden in 1834. The railroad caused Hightstown to grow into a prosperous agricultural and commercial center. It operated from 1832 to 1939, when it took its last run to the World's Fair in New York. Passenger service had ebbed long before that due to the influx of the automobile. Automobiles had taken their toll on the railroad, and the train became a thing of the past. (R&KP)

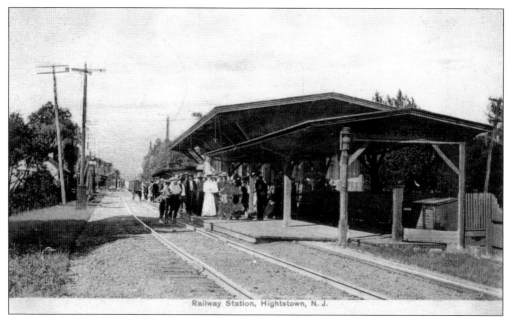

On September 12, 1867, *Hightstown Gazette* editor Jacob Stults described this new passenger depot as a great improvement over the former one. The new depot was located between Morrison (now Rogers Avenue) and Stockton Streets with a platform extending along the entire structure. It contained two "commodious" waiting rooms with a ticket office and telegraph room between. (R&KP)

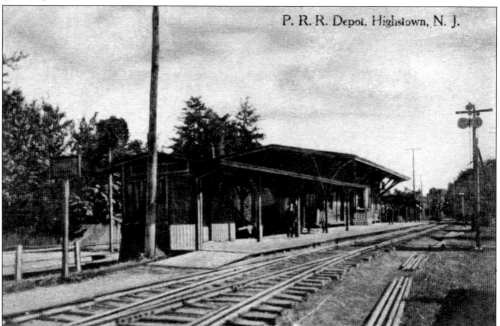

The Pennsylvania Railroad (PRR) depot is pictured here around 1913. The passenger depot of the Pennsylvania Railroad, formerly the Camden & Amboy Railroad, was located on the west corner of North Liberty (now Railroad Avenue) and Stockton Streets. The Camden & Amboy Railroad reported carrying 110,000 passengers during its first year of service. (R&KP)

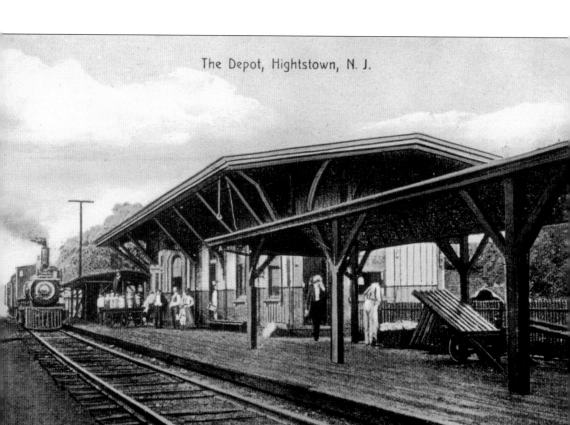

The Depot, Hightstown, N. J.

This view of the Hightstown depot's passenger station is dated 1910. Further examples of the railroad's effect on Hightstown can be seen in the town's architecture. By the end of the 1860s, Stockton Street, North Main Street, and South Main Street had all become fashionable places to live. Between 1830 and 1870, the town's population increased 13 fold. Eventually farm traffic became so important that an auxiliary line, the Pemberton & Hightstown Railroad, opened in 1868 to bring produce from farmlands in the east to Hightstown to be shipped north and south on the Camden & Amboy Railroad. The tracks of the Pemberton & Hightstown Railroad met the tracks of the Camden & Amboy Railroad in front of the Central Jersey Farmers' Cooperative Association complex on Route 33 in East Windsor Township. There was a turntable and an engine house built at Hightstown Junction. By 1915, sixteen trains per day stopped in Hightstown. (R&KP)

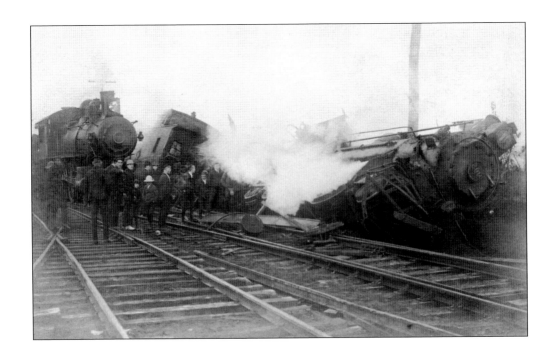

Mixed signals may have caused this train wreck in 1906. Although there is a double track, it is possible that the two trains were on the same track at the wrong time. There were many such terrible tragedies over the years on the railroad. It took railroads several decades to improve train-control practices and adopt safety devices sufficient to make railroad travel truly safe.

Four

CELEBRATIONS AND
OLD DOWNTOWN

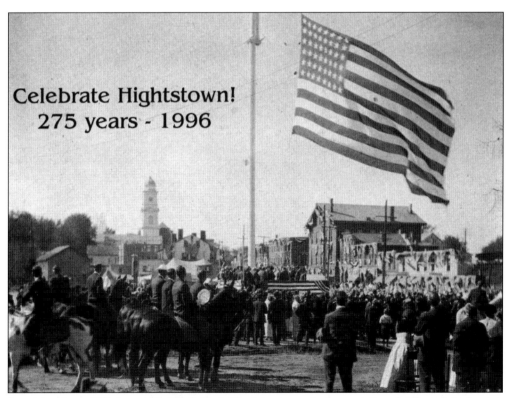

In celebration of Hightstown's 275th birthday, this postcard was reproduced. The original was a photograph of the dedication of the 100-foot-tall flagpole erected at the corner of Main and Franklin Streets in October 1921 to honor the veterans of the Civil War, Spanish-American War, and World War I. The First Baptist Church and Hutchinson Hall can be seen in the background. (R&KP)

This is the bicentennial anniversary celebration in 1921. Parade marchers are assembling for Hightstown's 200th birthday and the dedication of the Memorial Flagpole. Construction of Memorial Park at this site followed three years later; it was dedicated on Armistice Day, November 11, 1924. (R&KP)

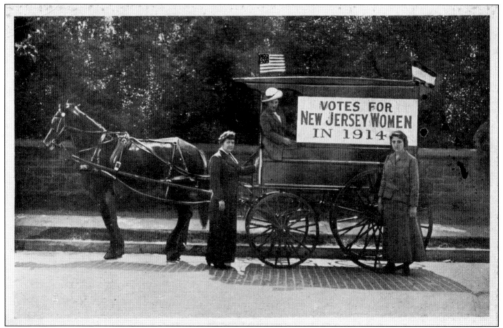

This photograph shows early proponents of women's suffrage, which was passed in 1920, part of a gradual improvement in women's rights starting in the 19th century. The First World War provided the first opportunity for women to take on traditional male jobs, so it was not surprising that women were given the same political rights as men a few years later.

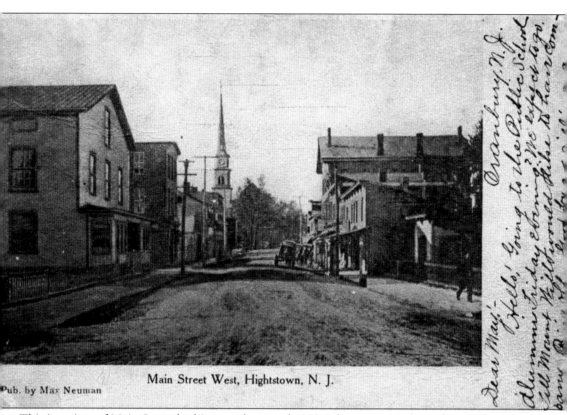

Main Street West, Hightstown, N. J.

Pub. by Max Neuman

This is a view of Main Street looking south around 1900. The Gross Brothers Flour and Feed Mill can be seen on the left. The buildings on the right were the First National Bank and Davison's Department Store. The Rocky Brook passes under the street in the foreground. It is fed by Peddie Lake waters that flow over a dam and were then used by the mills to turn their machinery. (R&KP)

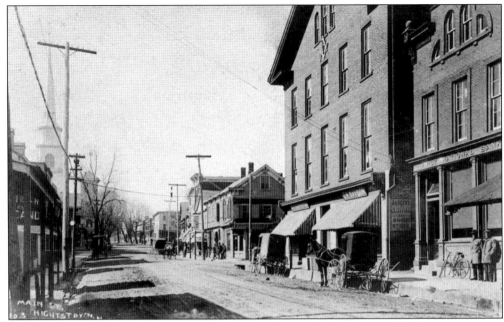

This south-looking view of Main Street around 1900 shows the former First National Bank and Hutchinson Hall (later the J.V. Davison Department Store) in the right foreground. The Cunningham Building, pictured before its 1906 reconstruction, is beyond those buildings, past the intersection of Main and Stockton Streets. The Gross Brothers Mill is on the immediate left. The steeple of the First Baptist Church can also be seen on the left. (R&KP)

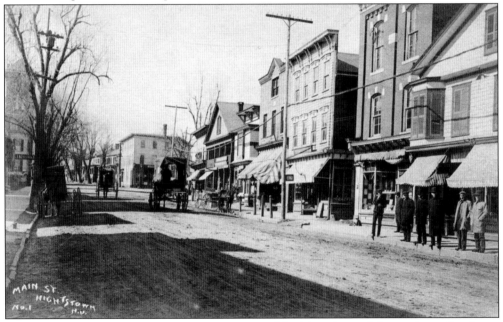

This c. 1900 image shows the three-story Dawes Hall building, beyond the carriages. Dr. Aaron Dawes practiced there as a dentist, and over the years, his building was used as a post office. When the water fountain was established, many new businesses sprang up along "Fountain Point." They included an oyster saloon, a grocery store, a shoe store, and Boud Cole's Jewelry Store. (R&KP)

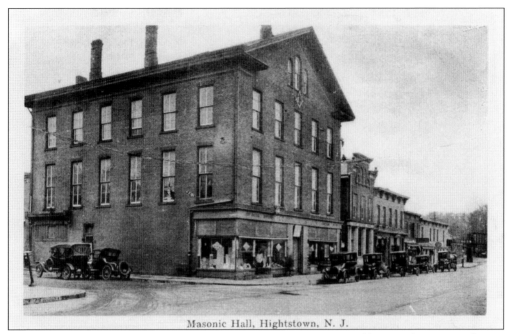

Masonic Hall, Hightstown, N. J.

The Masonic lodge and J.V. Davison's Department Store are pictured here at the corner of Main and Stockton Streets around the 1920s. The second floor was a favorite gathering place for events, festivals, suppers, and lectures. Horace Greeley lectured there, and numerous galas were held. The building is currently owned by and houses the Allen & Stults Company, an insurance agency since 1881. (R&KP)

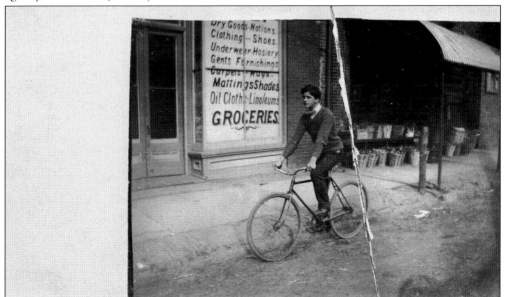

This image shows a bicyclist passing J.V. Davison's store around 1905. Davison purchased the store from C.W. McMurran in 1885. In 1907, J.V. Davison had a controlling interest in the Hightstown Smyrna Rug Company. In 1915, two of Davison's sons, C. Herbert and Howard C., sold their interest to their brother Joseph B. Davison, who owned the store until it was sold to National Sales Stores in 1926. (R&KP)

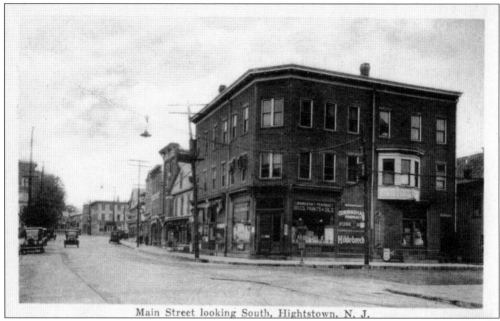

Main Street looking South, Hightstown, N. J.

This corner has witnessed Hightstown history since the early 1800s, when Britton's Tavern was built on the southern corner of the "Road to Prince Town" where it intersected with York Road. In 1884, the corner property was sold to D. Hart Cunningham, who built a new large three-story building that was enhanced by the bay window on the second floor. The building housed a drug store, and still does to this day. (R&KP)

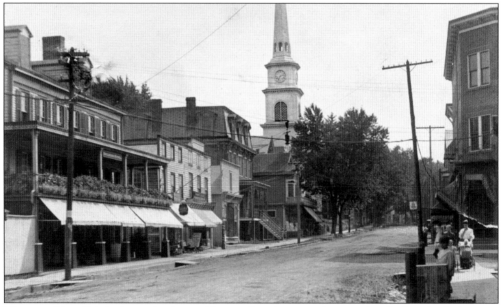

The east side of Main Street is pictured here. This photograph was taken before the lightning-strike fire on June 12, 1911, that led to a reconstruction of the steeple. The Railroad Hotel is in the left foreground, followed by Mount's Stationery Store and Turner's Bakery, the post office, the Smith Building, C.C. Blauvelt's Millinery and Dress Goods Store, Eaches Memorial Chapel, and the First Baptist Church. (R&KP)

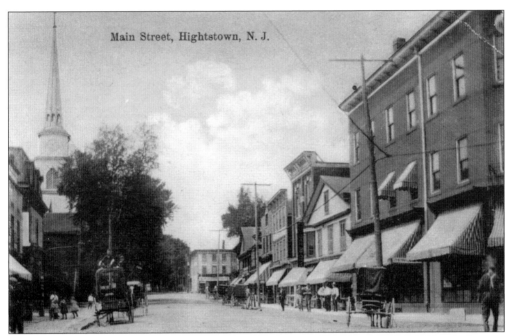

Shown here are Main Street and the First Baptist Church prior to the fire of 1911. On the right is Cunningham's Drug Store, C.R. Chamberlin's Men's Store, Wilson Brothers Butchers, Frank Perdoni's Fruits & Confectionery, and Henry Weller, Cigar Manufacturer. Further down on the right side was N.C. Schlottman, Plumbing & Hardware, and at the corner of Mercer and Morrison Streets was Joel W. McDaniel, Harness Maker. (R&KP)

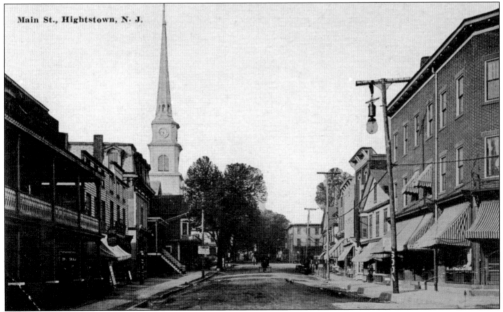

The streetlight on the utility pole on the right is an arc lamp, a style of electric lighting that was installed on Main Street in 1899. Previous lighting in the Main Street area was by oil lamps on 10-foot-high poles lit by lamplighters. During the summer of 1913, these electric arc lamps were replaced with tungsten lamps, typical of today's filament light bulbs. (R&KP)

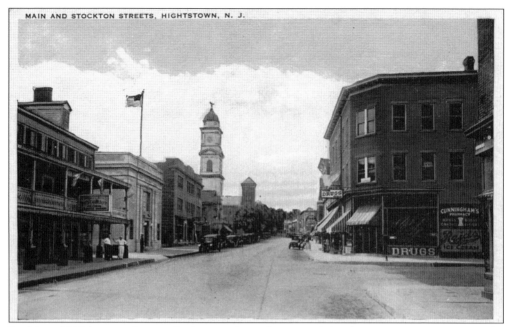

In this c. 1912 image taken at the intersection of Main and Stockton Streets, one can see the Cunningham Building on the right and Scheible's Hotel, the First National Bank (with the flag), the First Baptist Church, and the Universalist church on the left. No electrical lines are visible as in the later view below. (R&KP)

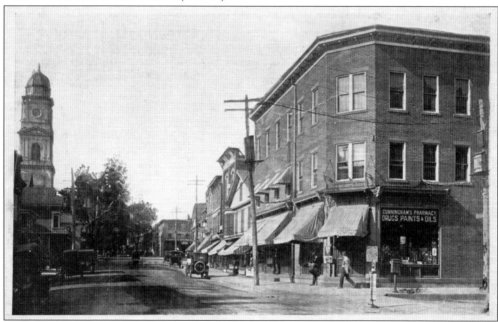

A view of the corner of Main and Stockton Streets around 1915 shows the Cunningham Building on the right. The rounded top of the First Baptist Church indicates that the photograph was taken after the reconstruction of the church, which was caused by a lightning-strike fire on June 12, 1911. Around 1915, the Electric Light and Power Company of Hightstown ran electric lines through Hightstown. (R&KP)

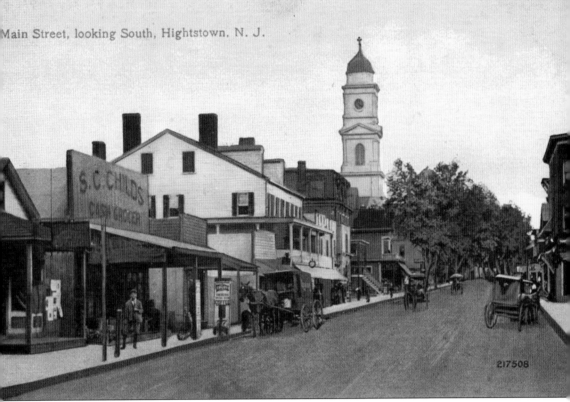

Main Street, looking South, Hightstown, N. J.

This is Main Street looking southeast toward the First Baptist Church of Hightstown. It shows the steeple with a peaked tile roof, demonstrating that the image was taken after the 1911 lightning-strike fire. The stores shown are Dennis' Garage (which had a capacity for 32 cars), the S.C. Child's Grocery, Scheible's Railroad Hotel, the Smith House, and C.C. Blauvelt's Dry Goods and Millinery Store. The latest in silks, trimmings, and millinery were sold by Blauvelt's wife, Nellie, on the second floor. In 1913, the town was shocked and saddened when its mayor, Charles Coatsworth Blauvelt, and his family moved to Pasadena, California. The highly respected Blauvelt family had a tradition of serving as mayor, from the first mayor of Hightstown, Dr. Charles G. Blauvelt (1853–1855), his son Joseph S. Blauvelt (1859–1861), and his grandson Charles Coatsworth Blauvelt (1911–1913). C.C. Blauvelt had been instrumental in establishing the water and sewer system in Hightstown, as well as the electric company and many other improvements to the town. (R&KP)

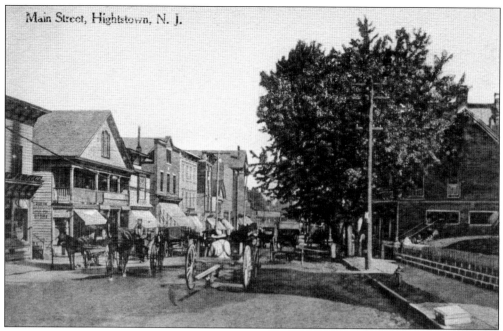

This image was taken from the Fountain Point, looking north. Horse-and-buggy transportation and electric poles foreshadowed the changes to come. The "horseless carriage" automobile would soon be on the road, with the first one puttering through Hightstown in 1900. It was just a matter of time before everyone would be driving, including women. Nettie Stults was the first female in Mercer County to receive a driver's license. (R&KP)

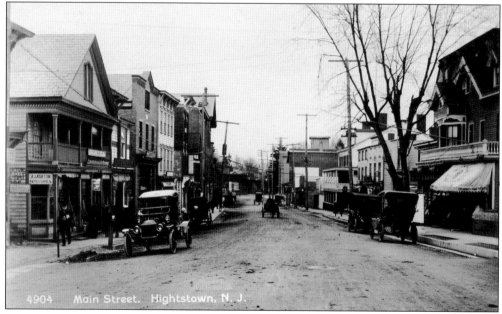

In this view from Fountain Point, the electric poles indicate that it is around 1915. Shoppers might have been patronizing Thomas Mason & Son Store for the latest styles in shoes and boots, ladies' dresses, and groceries. They also might have shopped at Harvey G. Rue's Drug Store and Thomas & Taylor Blue Flame Oil and Gasoline Store. (R&KP)

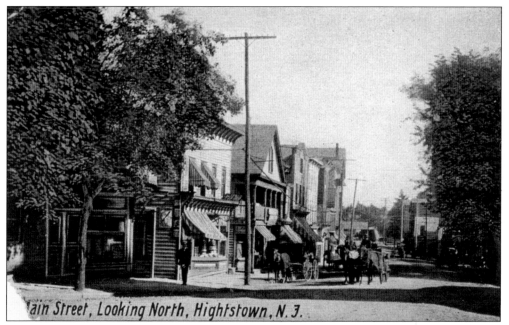

This is Main Street looking north from Fountain Square around 1915. Residents patronized Fiestal's Candy, Fruit and Ice Cream Store, located on the corner of Main and Mercer Streets and Rogers Avenue; the Main Street Bakery, owned by H.W. Robbins; or Sam Ford's 5 & 10 Cent Store. They may have stopped in Henry Weller's Cigar Shop to purchase fine cigars, pipes, pouches, and tobacco of any kind. (R&KP)

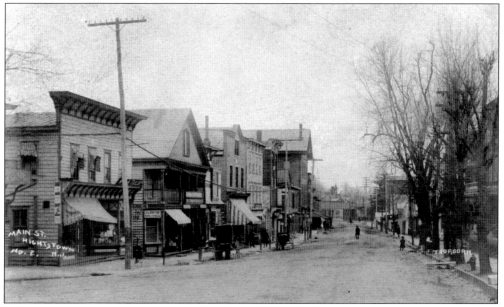

Seen here is a c. 1915 view of Main Street looking north from Fountain Point. The railroad trestle crossing over North Main Street is seen in the far distance. The stores on the west side of Main Street included Rue's Pharmacy, Weller's Cigar Store, Perdoni's Fruits & Confectionary, Forman's Hardware, and C. Boud Cole, Jeweler. Hightstown's businesses, aided by the railroad's stimulation of commerce, were flourishing. (R&KP)

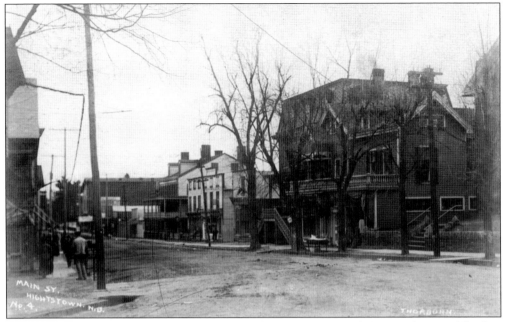

This c. 1915 view is of Main Street's east side at the intersection with Rogers Avenue. The first building on the right is C.C. Blauvelt's Millinery, Dress Goods and Trimmings Store, and next is the three-story Smith Building, which once housed the First National Bank. To the left are the post office, Turner's Bakery, Mount's Stationery Store, and the Railroad Hotel. (R&KP)

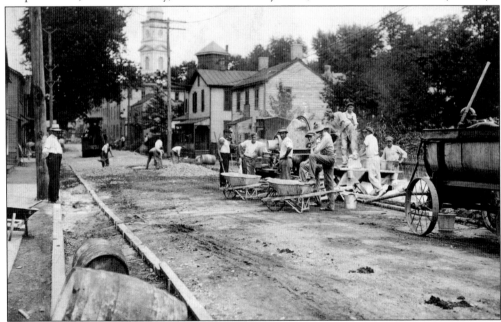

In this c. 1920 photograph, work crews work on the paving and adding of curbs to Mercer Street, now New Jersey State Highway 33 from Trenton to Asbury Park. Its humble beginnings were as a Lenni Lenape Indian trail, and later it became the Bordentown Amboy Turnpike. The Camden & Amboy Railroad had the same starting and ending points and ran parallel to the turnpike through Hightstown. (R&KP)

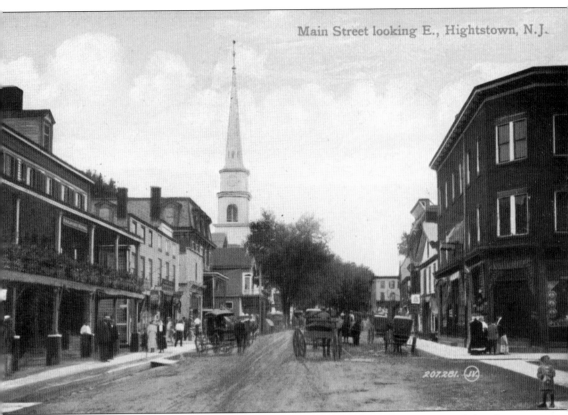

This is the heart of downtown Hightstown. In 1906, D.H. Cunningham erected the three-story brick building on the right. It replaced the old Washington Hotel that had operated since the early 1800s. The new building contained an enlarged drug store and space for two stores on Main Street. W.F. Dilatush's Meat Market and Oscar T. Fenton's watch and jewelry business occupied the stores. The second floor had two offices, a residential flat for the Fenton family, and a storeroom. On the left was Scheibles Hotel, also known throughout the years as the Railroad Hotel. In this photograph, Scheible's famous Geranium Balcony can be seen. John G. Scheible owned the hotel from 1886 until he retired in 1925. Scheible's Hotel was the first place in Hightstown to be wired for electricity. According to newspaper reports, people would go down to see his wonderful lights well before it became commonplace to have interior lighting. When Prohibition was passed, he closed the tavern and opened an ice cream parlor and restaurant. (R&KP)

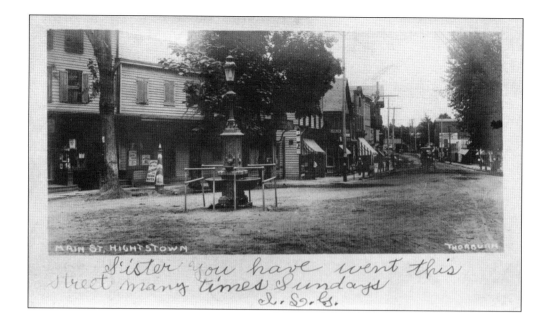

Pictured are two c. 1914 images of the fountain and Main Street. The fountain was erected in 1896 and was proudly described by the *Hightstown Gazette* as standing on the crosswalk from Dawes Corner to C. Boud Cole's Store on Main Street at the foot of Mercer Street: "It has two large basins for horses, two faucets for men, and two small basins at the bottom for dogs." The fountain was removed in 1915 when it was found to be in bad condition. Today this location sports a fountain again, with two bronze horse heads and carvings following the history of Hightstown.

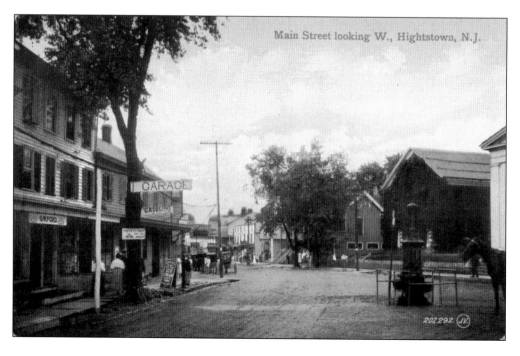

Five

THE BIG VIEW

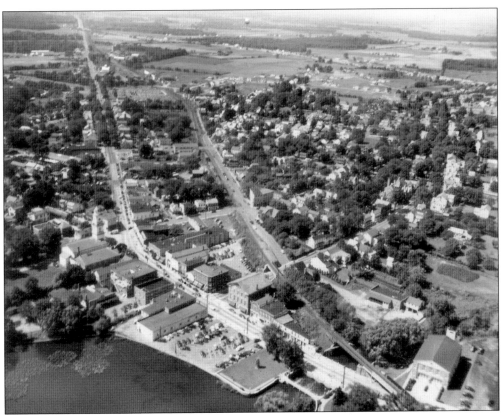

This photograph was taken around 1948 and is particularly interesting as not only downtown Hightstown is visible, but also East Windsor. In the distance, Route 130 can be seen running left to right through a mainly rural expanse of farms and woods. Notice the houses and businesses along Mercer Street, where the post office and bank are now. Also, the neighborhood in the area where the federal housing authority is now looks quaint with its trees and small houses, even from this high up. Hightstown was a much different place just a short time ago. (RHP)

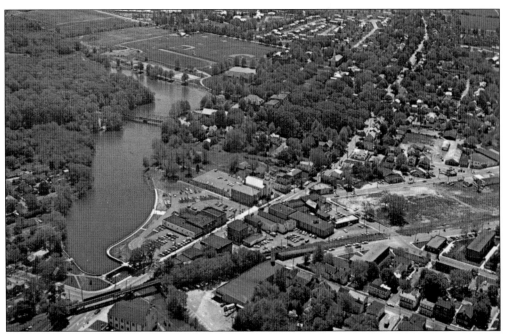

This aerial view of Hightstown looking south shows Peddie Lake stretching to the Peddie School's campus. The commercial district is also pictured, including Main Street's parking lot, the former long building of the Hights Theater, and the intersection of South Main and Mercer Streets. The railroad's trestle over North Main Street is in the lower-left foreground. (Dr. DM)

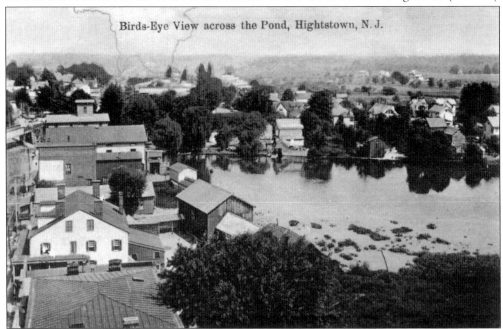

A beautiful birds-eye view across the pond is pictured here. This photograph of the east side of Hightstown's Main Street was taken from the steeple of the First Baptist Church. Among the structures pictured are Scheible's Railroad Hotel and the Gross Brothers Mill, which was destroyed in the 1920 fire, along with the building between the mill and the hotel. (R&KP)

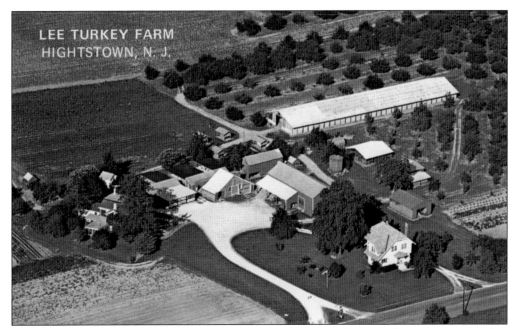

This photograph of Lee Turkey Farm was taken from the air above Hickory Corner Road in East Windsor. As a boy on his parents' farm, Richard "Dick" Hulse Lee raised 33 turkeys for a 4-H fair competition in 1938. With many years of experience raising turkeys and growing fruits, flowers, and vegetables, Dick and his wife, Ruth, took over the property in 1951. They renamed it the Lee Turkey Farm. (RWC)

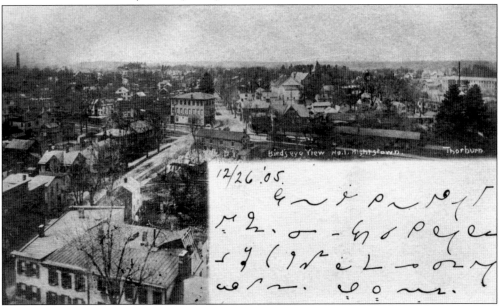

Local photographer Edward B. Thorburn took this photograph from the First Baptist Church tower looking west up Rogers Avenue in 1903. Samuel Fryer's Granite and Marble Works is on the right before the railroad tracks. The Pennsylvania Railroad passenger depot stands across the tracks. The large three-story building across the tracks and along Rogers Avenue is the J.S. Rogers and Son Company, which provided house furnishings. (RWC)

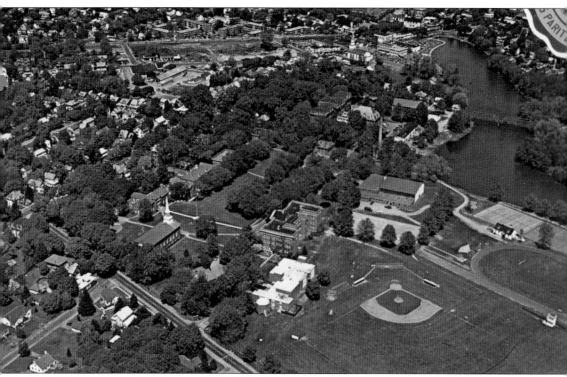

This aerial view of Peddie campus, looking north around 1972, shows a good view of the physical relationship of the campus to Peddie Lake (on the right) and the town of Hightstown. The abandoned railroad line dominates the upper portion of the view, with two open fields. Businesses were torn down in the name of progress to build the new post office building. (Dr. DM)

Six

CHURCHES ON HIGH

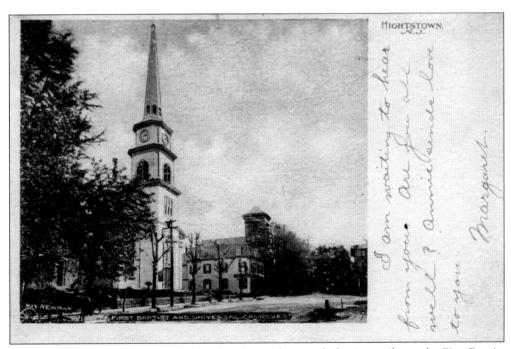

This photograph was taken around 1900, prior to the 1911 lightning strike to the First Baptist Church's steeple. The Baptist church, in the foreground, was established in 1859, and the Universalist church, in the background, was established in 1835. They brought an elegance and balance to Main Street's commercial district. The Universalist church is no longer standing. (R&KP)

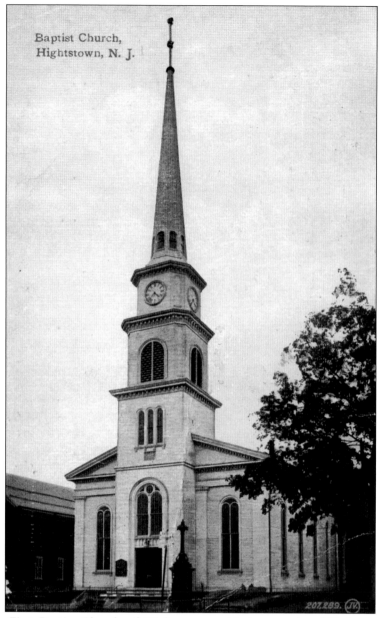

Baptist Church,
Hightstown, N. J.

This is the First Baptist Church of Hightstown, with its towering 168-foot steeple. The cornerstone of the church was laid on June 16, 1857. A month later, a new bell weighing one and one-half tons was added to the belfry. It was presented to the church by Thomas Hunt, Esq., of Brooklyn, a wealthy cousin of E.T.R. Applegate. While the church was being constructed, the mayor of Hightstown called a meeting of the town to consider placing a clock on the church. A resolution was passed, and a committee formed to solicit subscriptions to purchase the clock. The money was raised, and the clock was purchased for $350 from Sperry, a clock maker in New York City. With its four faces, it could be seen from any part of town. The steeple was a landmark in the community until it was struck by lightning on June 12, 1911. The lightning caused a fire that destroyed the steeple, along with the clock and the 3,170-pound bell. (R&KP)

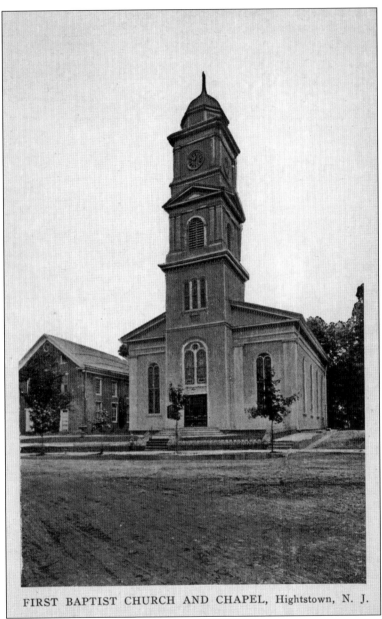

FIRST BAPTIST CHURCH AND CHAPEL, Hightstown, N. J.

The First Baptist Church was the first church established in Hightstown, in 1785. Their first meetinghouse was built on the same land that the present church stands on today. There have been several churches erected on this site; in 1834, the old meetinghouse was replaced by a new brick building. In 1857, the next church was built with its spire (opposite). This view of the First Baptist Church is from about 1915, after the rebuilding of the steeple that was destroyed in 1911. The new steeple was a more modest 116 feet. The bell was badly damaged and had to be recast. The beloved clock was replaced again by the town. The new clock, from the Seth Thomas Clock Company, was made of cast iron, the wheels and pinions were made of bronze and hardened steel, and it had watertight faces adapted for night lighting. It is still working today in our modern digital world. The building to the left of the church is the Eaches Memorial Chapel, named after Rev. Owen P. Eaches. (R&KP)

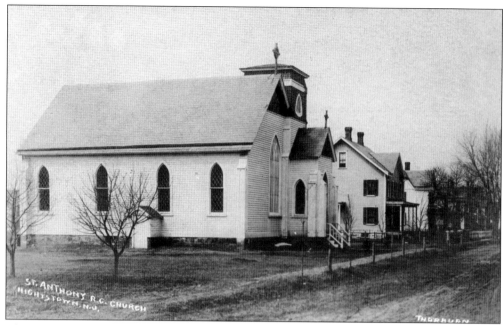

The St. Anthony of Padua Catholic Church was organized in Hightstown in 1874 as a parish with 25 congregants. The Franciscan Fathers revived the parish in 1892. Beautiful stained glass windows were added in 1918. The church has been updated several times in the past 50 years, creating a beautiful church for its parishioners. This postcard is stamped November 25, 1908.(R&KP)

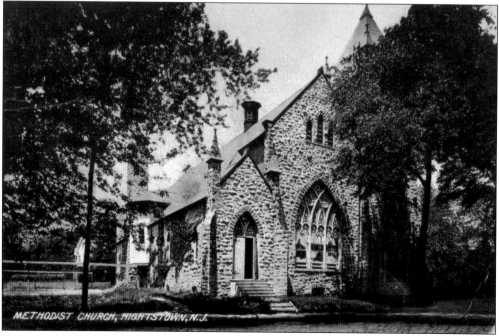

This was the third United Methodist church to be built in Hightstown. The first was a brick church built in 1853. In 1857, a larger frame church was built in the middle of Church Street. Early in the 1900s, this second church was sold to P.P. Chamberlin, who used it for concerts; it became known as the Opera House. It was destroyed by a fire on April 14, 1929.

The United Methodist church, built in 1898, is on the corner of Stockton and Church Streets. Located in the Stockton Street Historic District, its bell tower (partially hidden by the tree) is one of the district's landmarks. It features the sanctuary's primary entrances, each topped with lancet-arched stained glass windows. (R&KP)

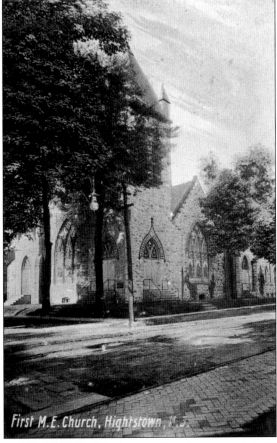

This is the northeast corner of the United Methodist church. Each facade of the church has large lancet-arched windows, buttresses, and spires. The building to the left was the first church built by the Methodists when they moved from Etra to Hightstown in 1835, and it is still in use today as apartments.

First M.E. Church, Hightstown, N.J.

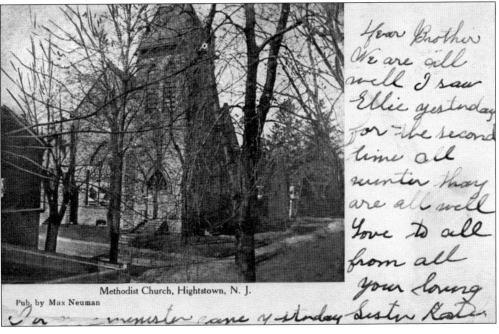

Methodist Church, Hightstown, N. J.
Pub. by Max Neuman

Dear Brother We are all well I saw Ellie yesterday for the second time all winter they are all well Love to all from all your loving Sister Roste

For ... minister came yesterday

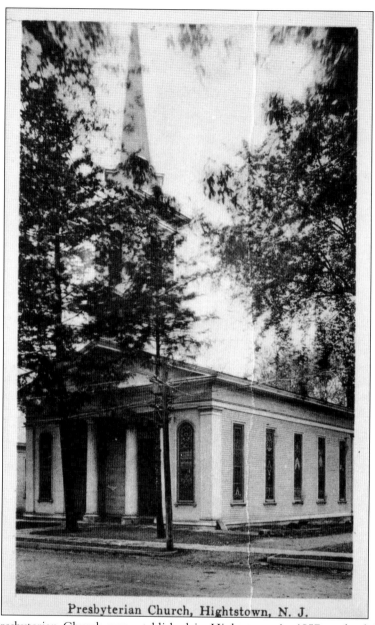

Presbyterian Church, Hightstown, N. J.

The First Presbyterian Church was established in Hightstown in 1857 on land donated by Benjamin Reed, a prominent and successful businessman and father of the Hightstown Volunteer Fire Company. The building committee was organized by chairman John Butcher and secretary E.T.R. Applegate. Its first pastor was Dr. Rufus Taylor. On June 17, 1858, the First Presbyterian Church was dedicated. A succession of strong pastors followed Dr. Taylor, and in 1888, Thomas Tyack, DD, became the pastor for the next 50 years. The church prospered and by the early 1900s had classrooms, a library, steam heat, electric lights, and a new pipe organ. In 1929, Fellowship Hall was dedicated and given as a gift from C. Herbert Davison in honor of his parents, Joseph V. and Louisa B. Davison. In January 1930, this church and its memorial windows were destroyed by a fire. The new First Presbyterian Church was rebuilt and dedicated on November 1, 1931. (R&KP)

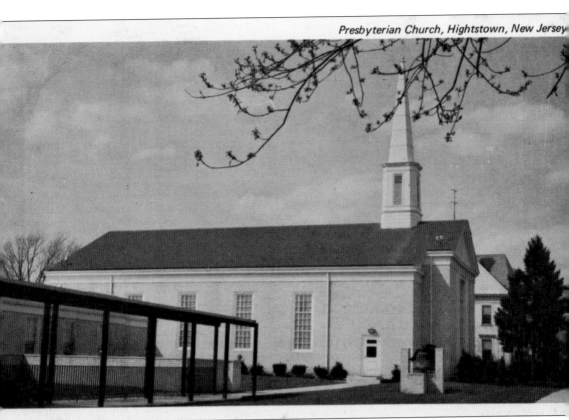

On Palm Sunday in 1969, the First Presbyterian Church burned down again. The present sanctuary on the site is its successor. Each time the church burned down, its steeple was rebuilt in the design of the original steeple. The present First Presbyterian Church's Christian Education Building is to the left of the sanctuary on North Main Street. Currently, the Better Beginnings Child Development Center is located in the education building. And 140 years earlier, it was also an educational site supported by the Presbyterian Church. The Hightstown Young Ladies Seminary was founded in 1864. It was taught by Dr. John McClusky and, later, Rev. William M. Wells. Even earlier, it was the site of the town's first schoolhouse. Built in 1793, it was the site of the first part-pay school, where local taxes paid part of the students' educations and the parents paid for the rest. (R&KP)

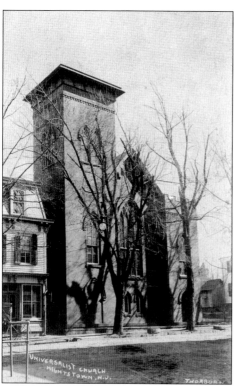

The Universalist church was located on South Main Street, approximately where the driveway of the Perritt Laboratory is today. It was established in 1835 after being moved into a building formerly used as the First Baptist Church's old meetinghouse, only two doors away from the new First Baptist Church. Albert Murray Norton, a local businessman and skilled woodworker, beautified the sanctuary with his carvings. (R&KP)

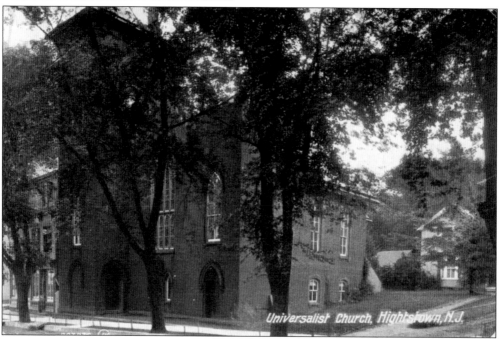

By the 1870s, the Universalist church in Hightstown had become a center of Universalism and had a flourishing congregation. However, by 1918 its congregation had dwindled and the church was closed. The building was razed in 1936 to make room for the new post office. The new post office later became Perritt Laboratory. (R&KP)

Seven

TOWN BUILDINGS
AND MEMORIALS

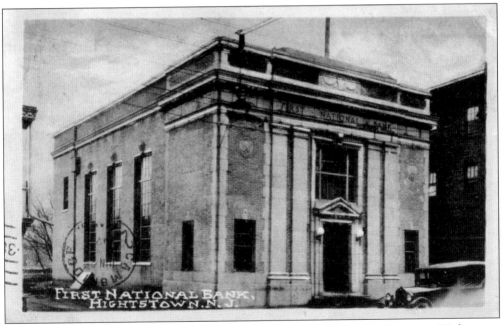

On September 2, 1870, a small group of prominent and public-spirited men in Hightstown organized the First National Bank of Hightstown. In 1922 it moved into this building, which was newly constructed on the east side of Main Street next to the Scheible's Railroad Hotel. After a generation of bank mergers followed by mega-bank mergers, this building is now the local branch of Wells Fargo Bank. (R&KP)

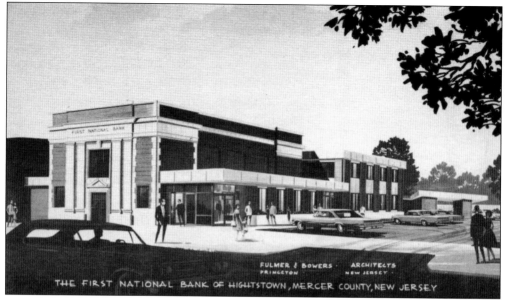

THE FIRST NATIONAL BANK OF HIGHTSTOWN, MERCER COUNTY, NEW JERSEY

FULMER & BOWERS ARCHITECTS
PRINCETON NEW JERSEY

In the 1960s, the First National Bank of Hightstown was modernized and expanded to include walk-up counters and a drive-through. Also included in the renovation was a floor across the two-story lobby inside the bank. Pictured here is the connection on the left to what is now the Tavern on the Lake restaurant, closing off the restaurant's incoming south light.

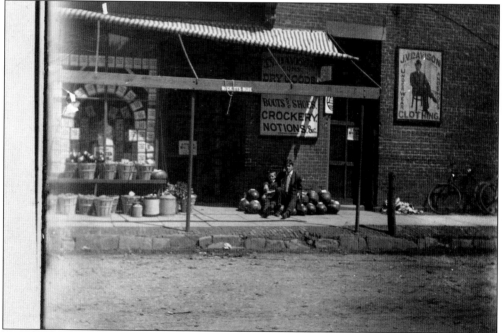

J.V. Davison's store on Main and Stockton Streets is pictured here. In 1885, Joseph Van Doren bought the general store from C.W. McMurran. The store was very successful and was enlarged to include a grocery store on the Stockton Street side and a clothing and shoe department on the Main Street side. In 1910, it expanded to the second floor to sell carpets and linoleum floor coverings. (R&KP)

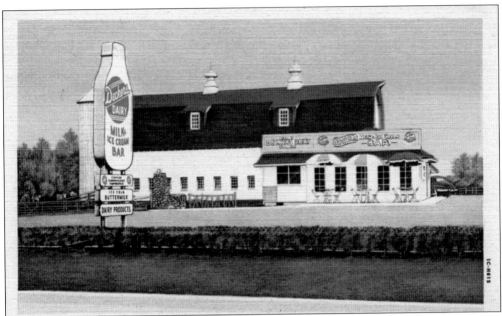

Conrad Decker established Decker's Dairy Farm in 1926. He modernized it and introduced homogenization. In 1940, he acquired a 52-acre dairy farm at the intersection of New Jersey Route 25 (now Route 130) and New Jersey Route 33, the site of Wal-Mart. The cows were Jersey Holsteins, and they were milked at the barn. The milk was then trucked to the dairy's processing plant on Monmouth Street in Hightstown. (RWC)

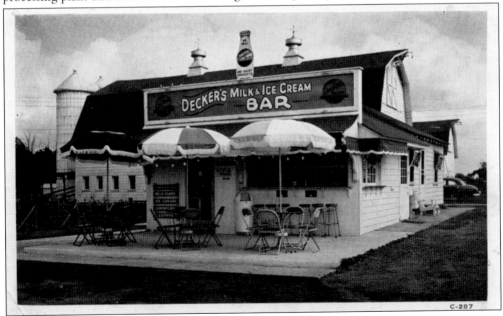

In the early 1950s, Conrad Decker started a milk and ice cream bar on the front of his property to promote his up-to-date dairy operation. At his stand he sold tasty sandwiches, sodas, sundaes, and all of the Decker's quality dairy products, including ice cream. Although successful, Decker closed the stand after three years because it created too many traffic problems on the heavily traveled highway. (R&KP)

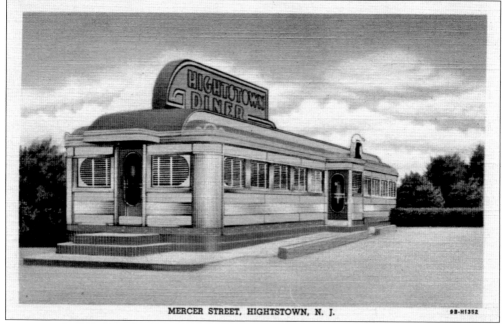

MERCER STREET, HIGHTSTOWN, N. J. 9B-H1352

In 1927, Nicholas Corcodilos established the Hightstown Diner at the corner of Mercer and West Ward Streets. This image is of a new concept of diners that replaced the earlier one in 1940. Carl Johnson, an airline designer, conceived an all-stainless-steel exterior and interior. People came from all over to see this modern eatery. With an expanded menu, the diner was a huge success. (R&KP)

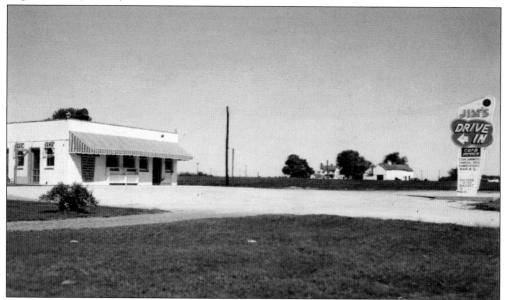

Jim's Drive-In was located on Route 130 South in what is now Robbinsville Township. Jim Corcodilos, Nickolas Corcodilos's brother, established the diner, which had a spacious dining room and cocktail lounge and was a popular stop along the long, rural stretch of Route 130 between Hightstown and Bordentown. Eventually, it was replaced by Jim's Country Diner. (R&KP)

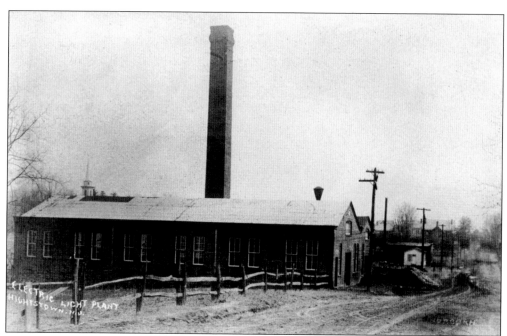

In 1898, the Hightstown Electric Light Plant opened on the north side of Bank Street, providing power to new arc streetlights and, soon, to machinery at the Hightstown Rug Company across the street. The first plant only provided part-time power a few hours per day. In May 1914, electricity was supplied on a 24-hour basis. In 1916, the Public Service Electric Company began operating it. (R&KP)

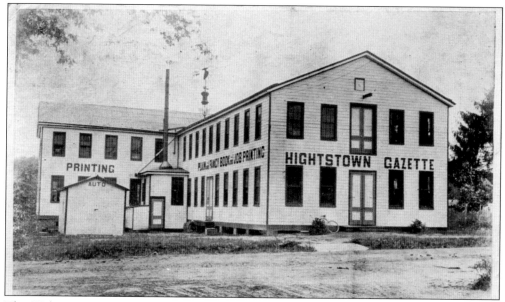

The *Hightstown Gazette*, formerly the *Village Record* from 1849 to 1861, was a locally published newspaper until the early 2000s, when its last editor, Kathryn Dennis, died. This 1909 photograph shows the office on Mercer Street. About 1930, the office and print shop moved to 114 Rogers Avenue. The *Hightstown Gazette* was the longest-running newspaper in Hightstown, an enormous asset for local history. (R&KP)

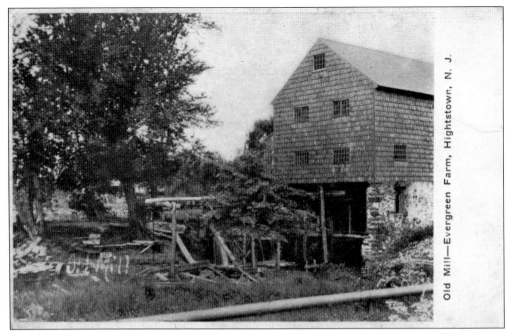

The mill on Evergreen Farm stood on the site of the current Meadow Lakes Retirement Community on Etra Road. Joseph South built the original mill in the late 1700s. South's descendants turned it into a fulling mill for the manufacture of woolen goods. Long after the mill had ceased working, the beauty of the setting and diversity of wildlife made the area very popular. (R&KP)

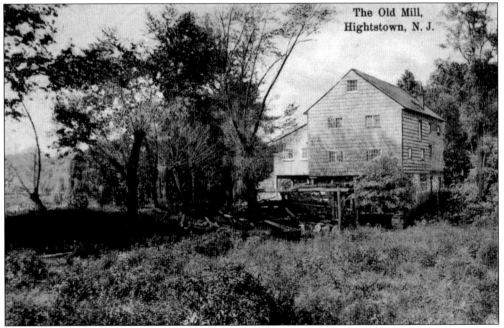

This is another view of the mill on the Evergreen Farm in Hightstown. It is easy to see why this picturesque setting became a favorite recreation spot in later years. At the end of the 19th century, John Jemison and his wife owned the farm and developed it into a summer resort for wealthy families from the cities, who arrived by train for vacations in Hightstown. (R&KP)

Mayor William H. Thompson built Evergreen Farm's Colonial Revival–style stone house in 1926. Today, it survives as the guesthouse at Meadow Lakes. In 1965, Meadow Lakes Retirement Village opened; it was designed to offer its residents similar vistas to those that were loved so long ago. (R&KP)

On the left is the Norton Cereal Rolling Mill, and at center is the Electric Theatre, a brick building built around 1895. Originally, the building was a furniture and wallpaper store; it then became a barbershop and pool hall. Around 1913, the silent movie *The Deerslayer* was showing in Hightstown. Warner Bros. bought its production company, Vitagraph, in 1925. Dennis' Garage was off to the right.

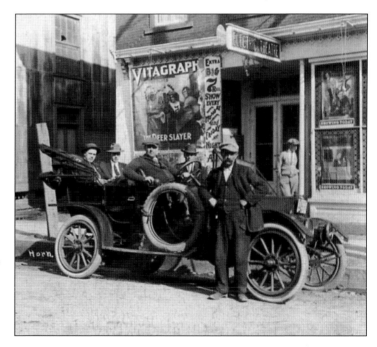

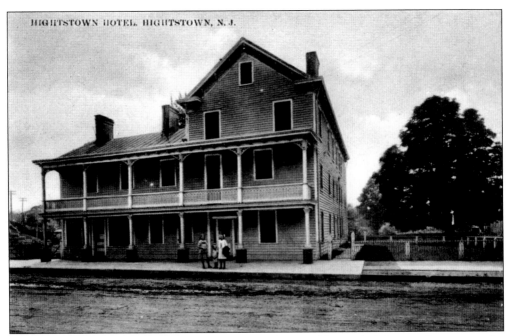

John and Mary Hight established their tavern/house here, and for nearly 200 years, it was a popular site for travelers. It was called Gabe's Big Red Hotel in 1840, Lantz's Hotel in 1886, and the Leland House in 1912. In 1919, the Peddie School purchased it and used it as a student dormitory until 1927, when it was razed in order to construct Hightstown Engine Company No. 1. (R&KP)

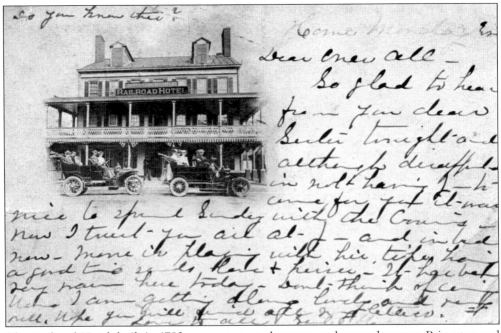

The Railroad Hotel, built in 1783, was a stop on the stagecoach route between Princeton and Freehold with stops on the Old York Road that went north and south, as well as the Bordentown and South Amboy Turnpike. It was always a popular gathering place for locals, organizations, and visitors passing through. It stood where Tavern on the Lake is today. (R&KP)

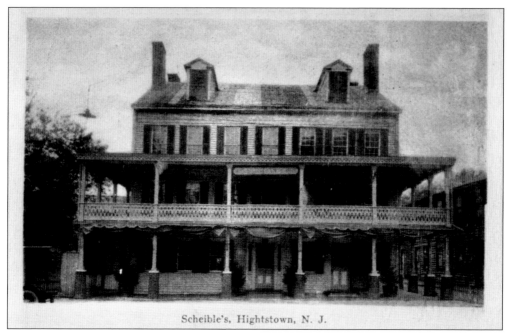

Scheible's, Hightstown, N. J.

James B. Richardson owned the Railroad Hotel in the 1860s. Because of its central, prominent downtown location, it was the scene of many gatherings, such as the raising of the "political pole," at which speeches were made and campaign flags were flown on the three-story-high hickory pole in front of the hotel. This postcard is dated 1922. (R&KP)

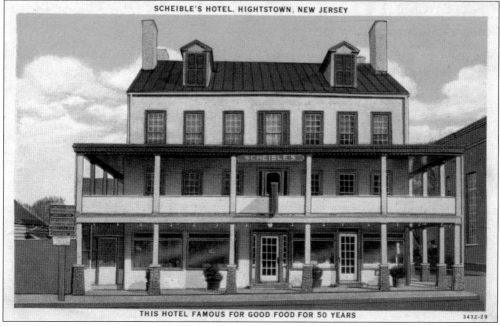

SCHEIBLE'S HOTEL, HIGHTSTOWN, NEW JERSEY

THIS HOTEL FAMOUS FOR GOOD FOOD FOR 50 YEARS

John G. Scheible owned the Railroad Hotel in the late 1800s and early 1900s. He renamed it Scheible's Hotel and made major renovations and additions. He created the lunchroom to the right of the hotel with a separate entrance and served sandwiches, cold drinks, and ice cream while maintaining the hotel on the left. (R&KP)

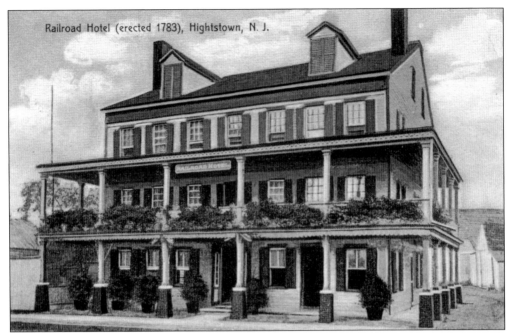

Railroad Hotel (erected 1783), Hightstown, N. J.

Scheible added the landmark Geranium Balcony to his hotel, creating a picturesque view of the building with its light colored walls and painted shutters. Visitors arriving from Stockton Street were presented with the sight of his beautiful hotel as they neared the end of the street at the intersection of Main Street. This postcard is dated 1909. (R&KP)

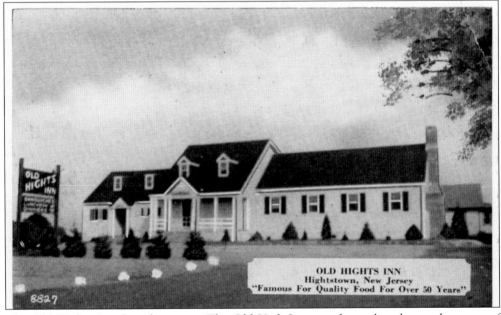

OLD HIGHTS INN
Hightstown, New Jersey
"Famous For Quality Food For Over 50 Years"

The Old Hights Inn, later known as The Old York Inn, was located at the north corner of Stockton Street and New Jersey Route 130 (old Route 25) in East Windsor Township. It was in a prime location for people traveling east-west and north-south. The Old Hights Inn came after the closure of the Railroad Hotel in downtown Hightstown and was representative of the beginnings of urban sprawl. (RHP)

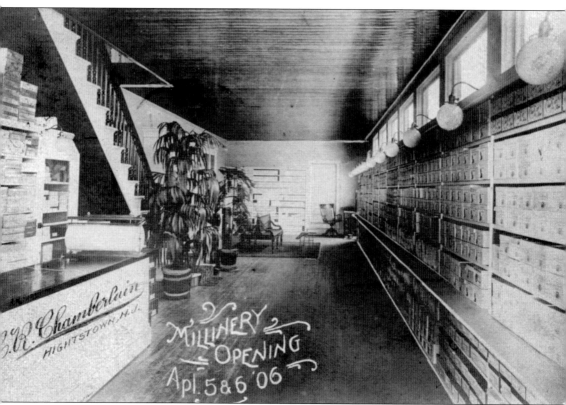

This postcard is dated 1909. C.R. Chamberlin's Millinery Store opened April 5–6, 1906, a Thursday and Friday, on the second floor of their store, just in time for Easter shoppers. They offered the latest in ladies' trimmed hats and accessories. The bigger news that weekend, however, was of their competitor J.V. Davison and the transfer of ownership of "The Corner Brick Store" at Stockton and Main to his sons, Joseph B., C. Herbert, and Howard Crosby Davison. Across the street on the west side of Main Street, Chamberlin's also sold shoes, boots, and foot rubbers. Other stores one might have shopped at that season would have been C.C. Blauvelt (who also sold millinery), Charles Keeler & Brothers (who sold fine shoes), and A.J. Ashton's. Unfortunately, Chamberlin's, along with other buildings to the south on Main Street, was destroyed by a fire on August 27, 1925. (R&KP)

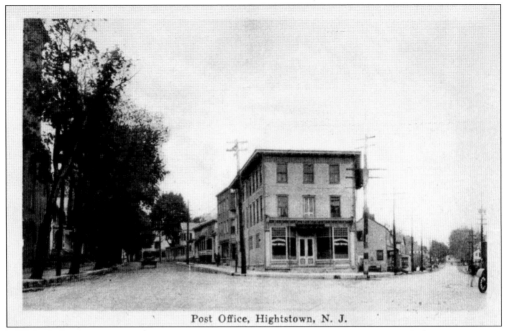

Post Office, Hightstown, N. J.

Pictured here around 1915, the Dawes Building—at Fountain Square and the intersection of Main, South Main, and Mercer Streets—served as the third and sixth location of the post office in Hightstown. It was owned first by Joseph Perrin and then by the Dawes family. A fire destroyed the building during an ice storm in January 1958. (R&KP)

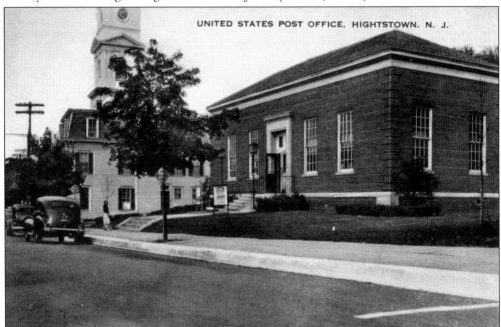

UNITED STATES POST OFFICE, HIGHTSTOWN, N. J.

In this view of the post office on South Main Street, the First Baptist Church's steeple is visible in the background. The post office was on the former site of the Universalist church, which was razed in 1936 to build the post office. The home of Charles Keeler was also torn down to make room for the post office. Perritt Laboratories now owns the 1937 post office building.

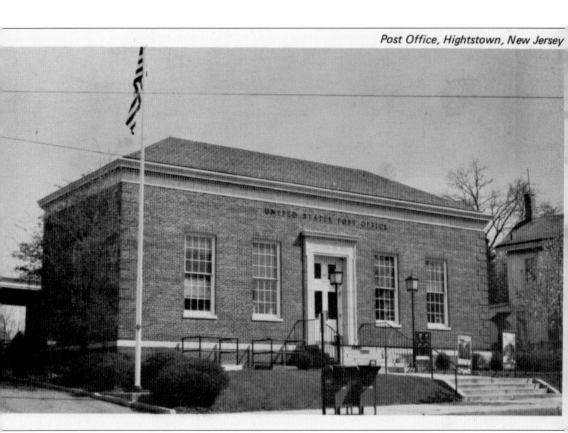

The post office on 145 South Main Street in Hightstown was dedicated on July 17, 1937; it was the seventh structure to be used as a post office in Hightstown. The long history of the local post office began on February 24, 1819, because Hightstown was a busy junction for stages and post riders coming to and from Princeton, Freehold, and Jamesburg. In 1936, the US Post Office Department decided to build a new structure with 6,300 square feet of space. Clarence S. Grover was the postmaster. There were congratulatory speeches and a parade with three bands, the councilmen, firemen, and J. Ernest Davison as parade marshal. The great increase in mail and population caused by the opening of the turnpike and accompanying research and industrial corporations as well as more residents required a larger building. The current post office at 150 Mercer Street, the eighth location, was opened on October 28, 1975. (R&KP)

OLD HIGHTS RESTAURANT

103 MAIN ST., HIGHTSTOWN, N. J.

OC-H1332

This is the right side of what is now the Tavern on the Lake Restaurant in Hightstown. The Ditcheos family built the original building in 1947. It was later known as the Ming Room, a Chinese restaurant. The windows on the right opened into what is now part of the 1960s addition to the former First National Bank of Hightstown. (RWC)

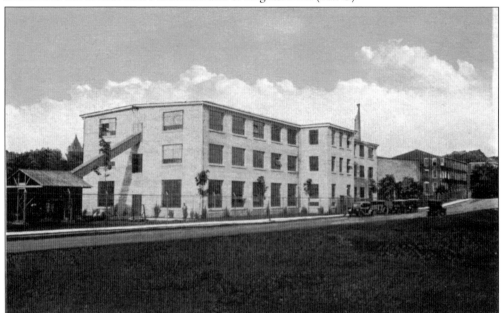

The former Hightstown Rug Company on Bank Street in Hightstown was established in 1898 as the Smyrna Rug Company. In 1922, it officially became the Hightstown Rug Company, and its owners were C. Herbert Davison and William H. Thompson. During its years in Hightstown, it produced quality rugs that were shipped throughout the United States, and employed 350 people throughout the Great Depression. (R&KP)

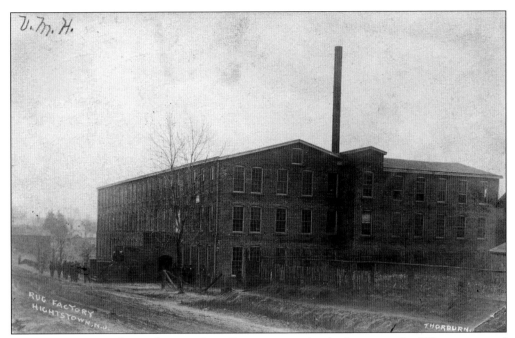

From 1907 to 1922, the Hightstown Rug Company was developing as a major US company and utilized electric motors on all its machinery. As an employer, it was known for dealing fairly with its workers and holding annual appreciation dinners and company picnics. It continued to prosper as its rugs were sold all over the world. It adapted to modern ideas and technology and manufactured parachutes during World War II. (R&KP)

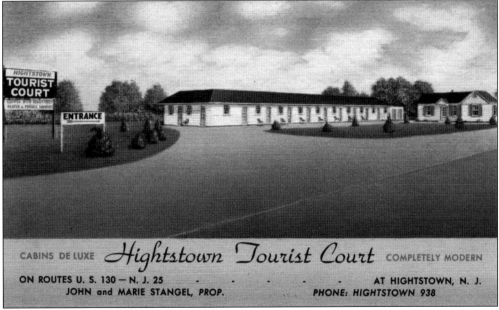

Travelers exploring New Jersey could stay at the modern Hightstown Tourist Court, located on Route 130 and New Jersey Route 25, on their way to the shore, New York, or Philadelphia. Hightstown needed new motel lodgings after the war, and this was one that filled the need before the construction of the New Jersey Turnpike and Exit 8. (RWC)

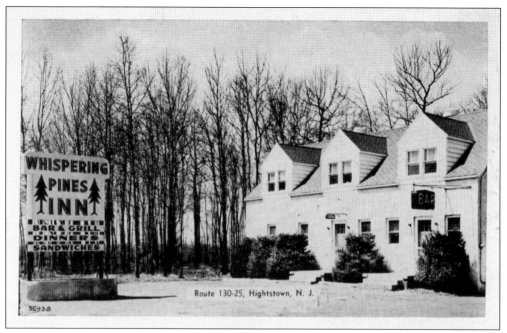

This roadside inn—located on what is today Route 130, near where Burger King stands— offered an inviting place to stop and eat during the late 1940s and 1950s. It was a regular hangout for Hightstown teenagers. East Windsor resident Amos Lattimore recalls going there to see boxer Joe Lewis and his prodigy in the early 1950s after Joe Lewis lost to Rocky Marciano in 1951.

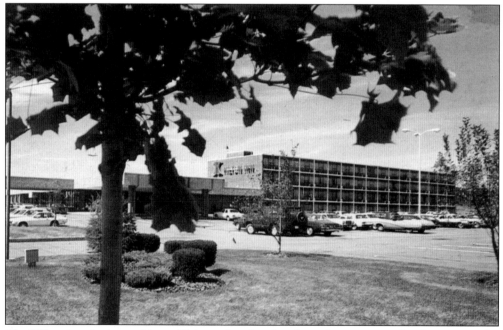

The Hilton Inn is pictured here. This modern hotel and conference center has been a popular location for weddings, conferences, and travelers in recent years. It is now a Holiday Inn with easy access from the New Jersey Turnpike's Exit 8. During the summer, the inn is filled with travelers to the Jackson Outlets and Great Adventure. (R&KP)

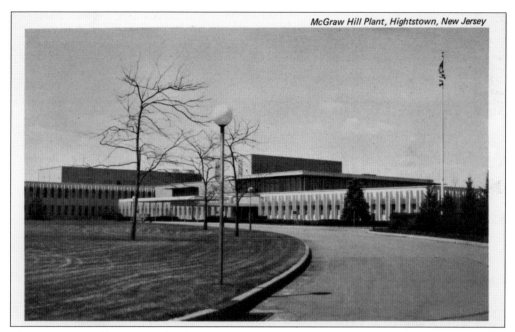

The McGraw-Hill Company has been a valuable part of the community for over 50 years. Built in 1958, it printed and shipped educational materials mostly to schools and colleges throughout the nation. The center had buildings on both sides of the road at the corners of One Mile Road and County Road 571. The north facility houses administrative offices, and the south facility contains a warehouse and distribution center. (R&KP)

This is a closer view of the Evergreen Farm's Colonial Revival–style house, which was built by Mayor William H. Thompson in 1926 (see the top of page 83 for the gates that mark the entrance). The back of this card reads, "The Presbyterian Homes of the Synod of NJ, Meadow Lakes, Etra Road, Hightstown, NJ. The Meadow Lake Guest House and South Lawn."

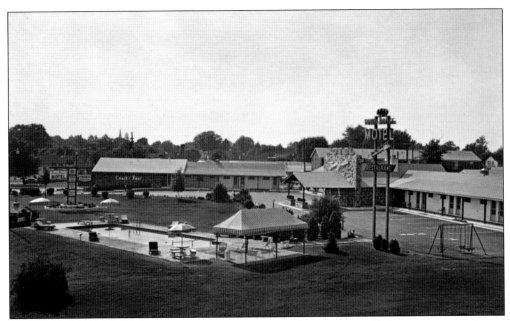

The Town House Motel was a popular stopping point for travelers at Exit 8 on the New Jersey Turnpike after it opened in 1951. The adjoining Coach and Four Restaurant was long beloved by locals as well as those from afar. Before the motel was built, it was the site of the Hightstown Athletic Association's baseball diamond and grandstands on Franklin Street. (R&KP)

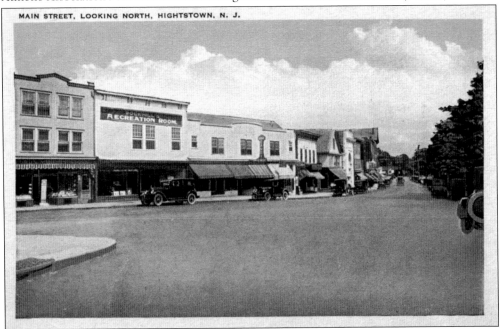

Pictured here is a c. 1930 view looking north from South Main Street. Straight ahead was Rockmill's Recreation Room, which had a billiard hall on the second floor. In 1915, the fountain in Fountain Point had been removed and the road was paved, leaving the fountain as a memory. South Main Street was originally two-way right into Main Street, causing many accidents. Today, it is a one-way section. (R&KP)

Eight

SCENERY AROUND HIGHTSTOWN

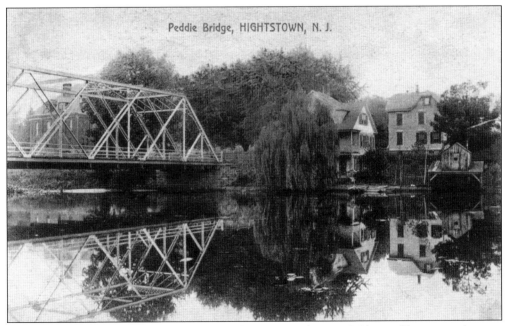

Reflected in the still waters of Peddie Lake, the East Ward Street Bridge and homes on the west side of the bridge are pictured here. The Arts and Crafts–style house partly obscured by trees was the home of Albert M. Norton. The owner operated a boathouse with boat rentals there for many years. (R&KP)

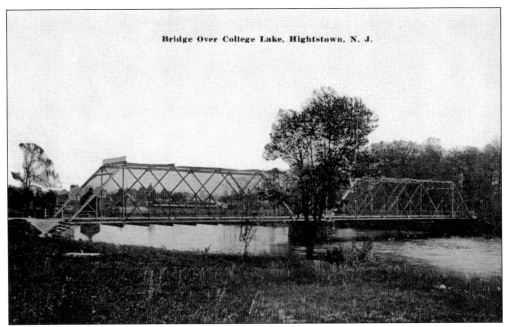

Bridge Over College Lake, Hightstown, N. J.

The Mercer County Freeholders approved the East Ward Street Bridge for construction on May 14, 1896, after seven years and many petitions by the residents of Hightstown and East Windsor. The bridge was 22 feet wide and weighed 151,215 pounds. It was opened on January 7, 1897. In the mid-2000s, the Department of Transportation widened it to include a pedestrian walkway. (R&KP)

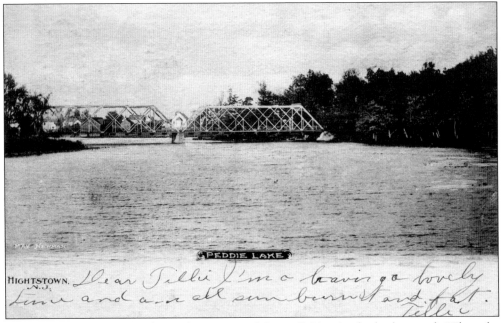

PEDDIE LAKE

HIGHTSTOWN, N.J. Dear Tilli I'm a having a lovely time and a-r all sun burnt and fat. Tilli

This view of Peddie Lake shows the East Ward Street Bridge in the background. When the mills were established along Rocky Brook, Peddie Lake was formed by the dam that was built by John Hight and others. The shallow lake had water lilies along the shore. The postcard was sent to Tilli Milforth of Lansdown, Pennsylvania, in 1906. (R&KP)

96

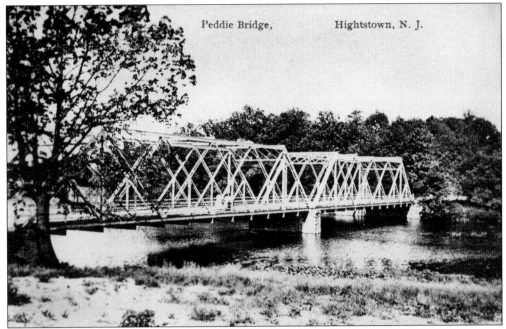

Peddie Lake had clean and clear water and was used by the residents of Hightstown for fishing, boating, and bathing in the summer and ice-skating in the winter. In the 1900s, pollution from farming runoffs and humans and animals living along Rocky Brook caused it to be clogged with vegetation, and it became unhealthy. (R&KP)

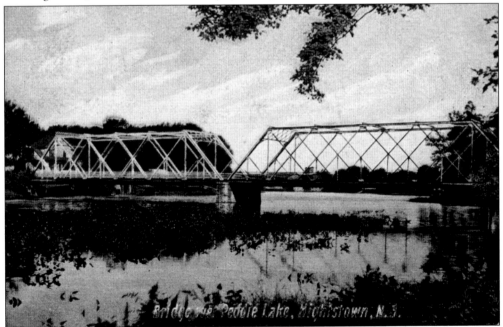

In 1916, the town had Peddie Lake dredged and returned it to a healthy status. A miniature beach was created, and the lake was again enjoyed by all. In the 1980s, it had to be dredged again in order to maintain it as a healthy lake. Today, it is still used by fishermen, boaters, and swimmers in the annual Hightstown Sprint Triathlon. (R&KP)

97

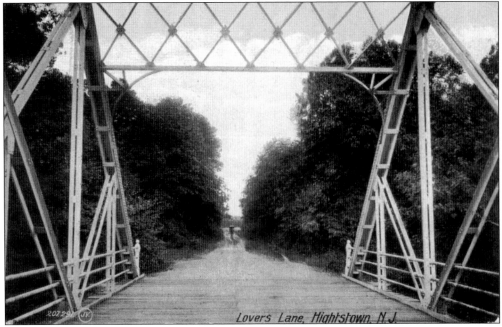

Pictured here is a view of the bridge over Peddie Lake at East Ward Street in Hightstown. The bridge has two spans made entirely of iron, except for the wood road surface. It extended Ward Street, which had ended at the west side of the lake, to Lover's Lane at Maxwelton, a wooded grove on the east side of the lake. The road surface has since been replaced and paved. (R&KP)

Seen here is a rare view of the bridge over Peddie Lake. This view from the west side of the bridge is looking to the east. On the left is a lakeside house with many balconies, gables, and dormer windows that was built by Albert M. Norton in 1900. The two ladies pictured on the bridge are crossing to Lover's Lane on the east side of the lake. (R&KP)

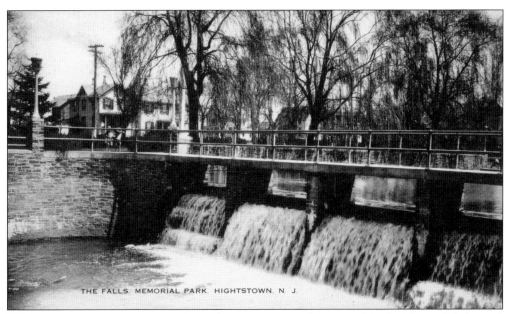

The dam and spillway have long been the centerpiece of Memorial Park. The park is located on the site of the largest fire in local history, which occurred on May 29, 1920. The Gross Brothers Flour and Feed Mills and a connecting walking bridge over the old dam were entirely destroyed, along with several other stores. The new walking bridge was completed in 1923 and existed until approximately 2009.

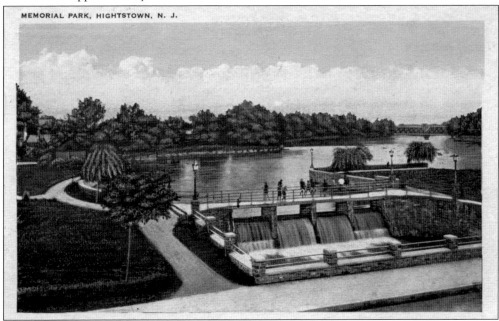

Memorial Park is comprised of properties from the corner of Franklin and Main Streets to the Railroad Hotel and a portion of Peddie Lake. They were purchased for $30,000 and deeded to the borough by a group of local town supporters—Mayor William H. Thompson, Joseph V. Davison, C. Herbert Davison, and Harry and David Gross—and the board of corporators of the Peddie Institute. This postcard is postmarked 1927. (R&KP)

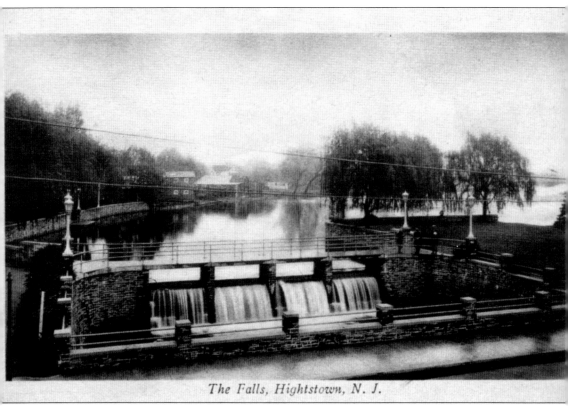

The Falls, Hightstown, N. J.

The land now known as Memorial Park was to be used for charitable, recreational, and municipal purposes, but more importantly, the land was to memorialize the town's military veterans by erecting a 100-foot flagpole dedicated to them. The flagpole was the first part of the gift to the soldiers from the previous wars. It was erected in September 1921. Next, the Hightstown Board of Trade developed a fundraising drive in which residents pledged $1 shares to raise $25,000 for the park fund. The park included a new dam, stone retaining walls, a walkway across the dam where the mills had been, and a boat landing with steps to the lake. Each subscriber to the fund received a certificate showing the number of shares pledged with an engraved triangle (see page 125) enclosing the inscription "The Shrine of American Independence" along with the service emblem of the war veterans. Memorial Park was dedicated to Hightstown and East Windsor's veterans on November 11, 1924, six years after the signing of the armistice ending World War I. This postcard is postmarked 1934. (R&KP)

Log-Cabin, Peddie Lake, Hightstown, N. J.

A large tract of land on the east side of Peddie Lake known as "Peddie Woods" was purchased and donated to Peddie School in 1898 by Elsie Peddie Sauvage, daughter of Thomas B. Peddie, the namesake of the school. The Peddie Fathers' Association erected the "scout house" on the lake edge of Peddie Woods in 1934. It had a large stone fireplace and is no longer standing. (Dr. DM.)

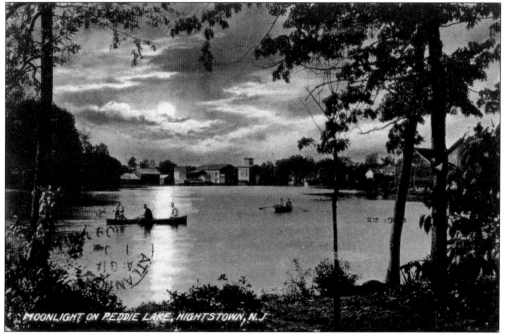

MOONLIGHT ON PEDDIE LAKE, HIGHTSTOWN, N.J.

Boaters enjoy Peddie Lake on a quiet moonlit evening. The mills can be seen in the background. This image was taken from the beautiful shores of "Maxwelton," also known as "Peddie Park" or "Peddie Woods," which was a favorite spot for romance. Peddie Lake provided many opportunities for boating, fishing, and enjoying the Memorial Park. (R&KP)

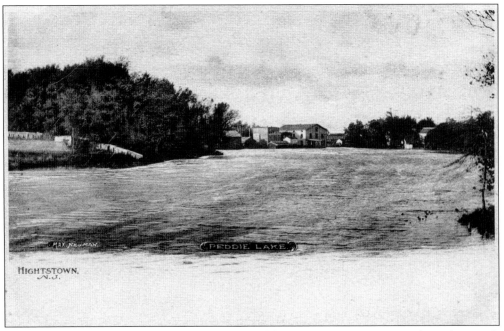

This view appears to be from a point on the Peddie Institute campus near where the tennis courts are situated today, or from Maxwelton (prior to the construction of the Ward Street Bridge) looking north into downtown Hightstown. Along the left bank, one can see what appears to be the end of Ward Street. (RHP)

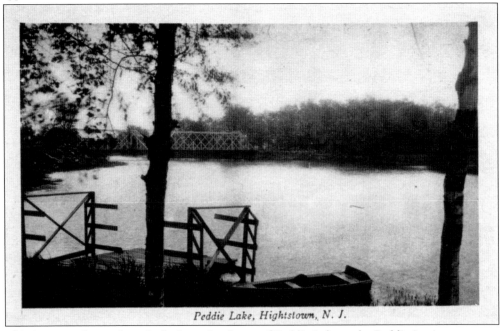

Peddie Lake, Hightstown, N. J.

This is a scene from a boat dock along the shores of Peddie Lake at the Peddie Institute campus around 1910. The Peddie School, as it is known now, has a competitive crew team with training facilities at Mercer Lake in West Windsor. Could this dock be the precursor to those facilities? This postcard is postmarked 1934 and was sent to Carlotta L. Davison.

This view of Memorial Park from the west side of Peddie Lake shows the gazebo at the top of the stairs leading from the boat platform. Today the gazebo is gone, but its foundation remains as the base of a monument to the military. The monument was dedicated to the Hightstown Memorial Library, which also exists at this site. (R&KP)

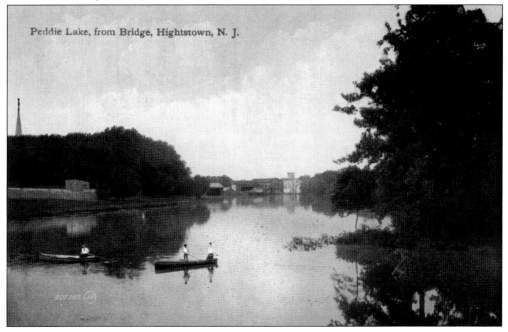

Peddie Lake, from Bridge, Hightstown, N. J.

The card title indicates that this photograph was taken "from Bridge." However, it appears to be much farther from downtown. The small brick building on the left is more likely an outbuilding behind Peddie Institute's Wilson Hall, as shown in the 1895 birds-eye map. The pointed steeple of the First Baptist Church towers over the trees at far left, indicating that the photograph was taken prior to 1911. (RHP)

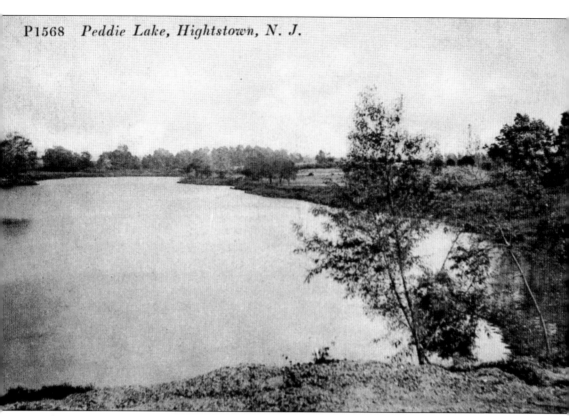

The eastern portion of Peddie Lake is pictured here with the Peddie School campus on the right. In those days, the lake had clean water with a shallow shoreline and numerous water lilies lining its shores. Fishing was easy, and boating and bathing were enjoyed by all in the summer, as was ice-skating in the winter. Conditions in the lake changed, however, as human and animal pollution from homesteads along Rocky Brook contributed to the buildup of islands of weeds in the lake. Boating became impossible, and the lake began to shrink. By 1913, the town decided it was necessary to dredge Peddie Lake; by 1916, the process was completed. A popular new beach was created on the shores of Peddie Woods above the bridge. On one very hot July day that year, over 100 people were bathing at this beach. The back of this postcard is dated October 25, 1916, and says, "Peddie-13, Princeton Freshmen-7; Some game. Will write later, Eddie dear. Bob." The photograph was taken by S.R. Ford of Hightstown. (R&KP)

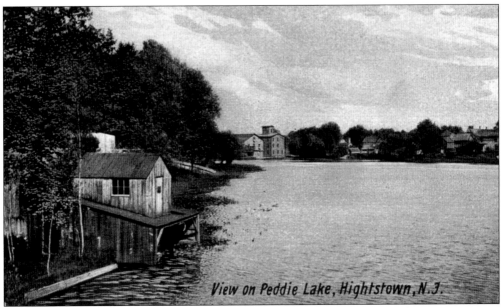

View on Peddie Lake, Hightstown, N.J.

Albert Norton's boathouse is in the foreground of this photograph of Peddie Lake, which was taken from the East Ward Street Bridge, and the Gross Brothers Flour and Feed Mills is at the far end of the lake. Albert Norton rented boats from this location. Boating, fishing, and swimming were popular sports in Hightstown at the time. This postcard is postmarked 1908, and on the back is written, "Spending my vacation here as usual and enjoying it." (R&KP)

A fisherman is photographed on the banks of Etra Lake—two miles east of Hightstown on Etra Road, or Mercer County Route 571, at the village of Etra in East Windsor Township. John Cosman, a miller in Windsor, created the lake for his gristmill around 1773. It became a summer destination for many vacationers from other parts of New Jersey and beyond. This image is postmarked 1907 and was sent to Miss Dahin.

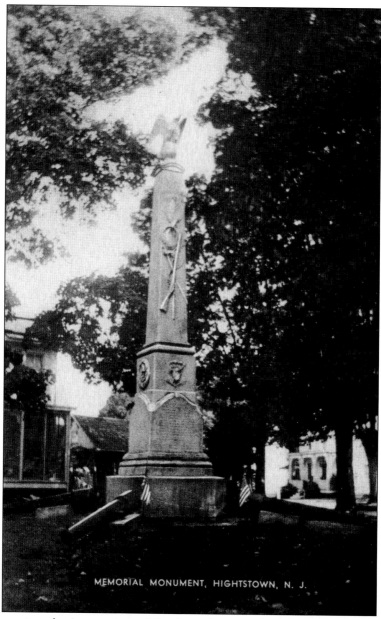

MEMORIAL MONUMENT, HIGHTSTOWN, N. J.

This monument at the intersection of Stockton Street and Rogers Avenue was erected to memorialize the 35 soldiers of the East Windsor Regiment of the Union army who lost their lives during the Civil War. The oration given on the day of dedication, July 5, 1875, included the following: "Impelled by [the] spirit of sympathy, we have willingly obeyed the summons of the 'East Windsor Soldiers' Monument Association' to render the tribute of our presence at least, to the memory of those who, during the war of the Rebellion, freely yielded up their lives in defense of their country. It is not only meet and proper for us to be here, engaged in this sacred office, but it is pre-eminently a duty, that, resting upon each, plainly commands us to render the homage of our fervent, heart-felt gratitude to those heroes, who only a few short years ago went in and out among us, in the familiar intercourse of daily life, but dying for us, have forever passed to that bourne from which no traveler e'er returns."

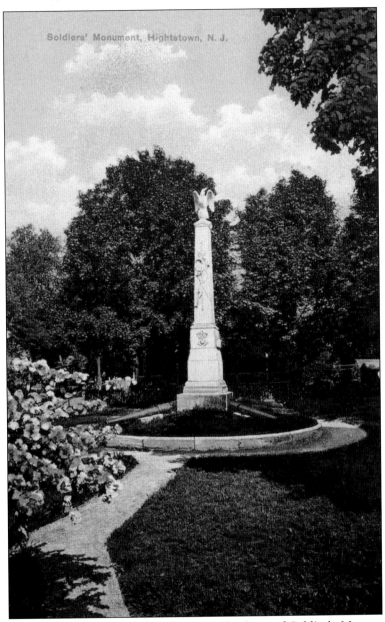

Soldiers' Monument, Hightstown, N. J.

Four Confederate Parrott rifles (cannons) rest at the base of Soldier's Monument, one at each corner. A life-size sculpture of an eagle is perched on the top. The names of the fallen soldiers, local men who died in the Civil War, are inscribed on the base of the monument. The monument and grounds are in the Stockton Street Historic District, which is listed in the National Register of Historic Places. Further recognition of the soldiers' sacrifice was given at the memorial in 1875: "How much more are these men . . . entitled to the exhibition of grateful feeling, when you recall to mind the fact that they did not hesitate to sanctify the cause that they defended with the baptism of their own blood, and bravely gained a victory for you at a cost of their own lives. A Republic may be ungrateful. But surely, surely not, when the gratitude demanded arises from a lively sense of her delivery from the very throes of death." This image is postmarked 1912 and was sent to Mrs. John Ely.

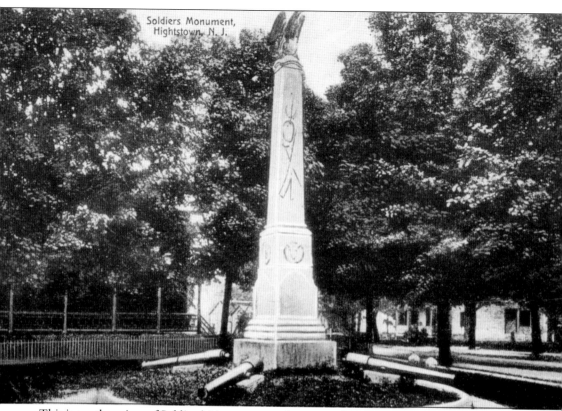

Soldiers Monument,
Hightstown. N. J.

This is another view of Soldiers' Monument and a vernacular Gothic dwelling beyond the trees that is still standing today. Its proximity to the street and center of town suggests that this home was constructed around 1870, just five years before the monument's dedication. The inscription on the monument reads, "In memory of the Heroic Volunteers of East Windsor Township who gave their lives as a sacrifice for their Country and Humanity in the suppression of the Great Rebellion of 1861–1865 this monument is erected by their grateful fellow citizens." This image is postmarked 1910 and was sent to Edna M. Conover by S.W. Rogers of Hightstown on July 21, 1910. The correspondence begins, "Dear Daughter," and discusses a social gathering Rogers had attended. It is signed "Papa." An oration compiled by Edward T. Green on July 5, 1875, states, "I do not suppose that anything could be more fitting—more expressive—more honorable to you and to those whose memory you revere, than by the erection of the beautiful monument this day to be dedicated."

This is a view of the New Jersey Turnpike near the Hightstown Exchange, Exit 8. Built from 1950 to 1952, the turnpike has a total length of 118 miles. From 1961 to 1971, the four-mile Fort Lee Extension was added. In its first full year of operation in 1952, the New Jersey Turnpike carried 17.9 million vehicles, an average of 49,200 vehicles per day at any point along the entire length, and generated toll revenue of $16.2 million. That year, it cost $1.75 to traverse the 118-mile length. Broken down per mile, the toll was 1¢ per mile south of New Brunswick and 2.7¢ per mile north of New Brunswick, reflecting the higher construction costs in northern New Jersey. According to the New Jersey Turnpike Authority, the turnpike today carries about 205 million vehicles per year, an average of 560,000 vehicles per day, and generates revenue of more than $350 million per year. It has had a major and continuing impact on the economy of the area.

The Washington Oak was once located on York Road (County Route 539) south of Eiler's Corner on the Hulit-Blasig farm in East Windsor Township, three and one-half miles south of Hightstown. The local lore is that it may have sheltered Gen. George Washington's troops when they marched down York Road during the Revolutionary War, although Washington himself never passed this way. This huge tree, a popular tourist attraction, succumbed to disease in 1960. Healthy white oak trees can grow to 100 feet tall with a trunk four feet across. The leaves are bright green on top and whitish underneath and turn red or brown in the fall; often, they will stay on the branches of younger trees in the winter. The outer hull of the historic frigate USS *Constitution* was built with white oak lumber. During the War of 1812, cannonballs from the British bounced off the ship's hull due to the strength and hardness of the wood. It was because of this that the ship was nicknamed "Old Ironsides."

Nine

THIS AND THAT

Pictured here is a report card issued by R.W. Swetland, principal of the Peddie Institute, in 1905. The unfortunate student was reported to have failed in Anabasis, the study of ancient Greek military strategy. Dr. Swetland served as headmaster of the Peddie School for 36 years (1898–1934) and was credited with its remarkable growth and excellent reputation. This report card was sent to J.V. Davison in 1905.

Shown here is a c. 1903 advertisement for the McCormick Light Draft New Four mower, which was used for weed cutting and grain harvesting. These machines were pulled by horses. The company also manufactured farm equipment such as reapers, corn binders, shredders, and headers. A McCormick brochure from 1903 stated that the mower was "specially designed for cutting on rough and stumpy ground." A McCormick binder was "offered to the agriculturalists of the world as a machine with the latest improvements, and one that can be relied upon to successfully harvest and save grain even when it is in the most unfavorable condition." According to McCormick, use of their machines allowed farmers to increase crops with the least work. "The farmer is striving for easier methods of doing things, better ways of living, and the attainment of all improvements which will help to live comfortably so that you can enjoy your work, and relish the free, fresh air and sunshine."

This is the reverse of the McCormick advertisement opposite. The supply dealer was H.D. Mount Farmers Cash Supply, which is stamped on both images. During the World's Columbian Exposition of 1893, an award was recommended for the McCormick knot-tying mechanism: "It is very doubtful that the next 50 years produces a more simple mechanism for this purpose." To this day, McCormick manufactures high-quality tractors and farm equipment. Cyrus McCormick invented a successful agricultural reaper in 1831 that was designed to do the work of five men. His innovation, leadership, and business sense ultimately led to the formation of International Harvester in 1902. By 1974, McCormick had manufactured five million tractors.

The Harvest Home of the Hightstown Baptist Church will be held in the grove back of the Church on Wednesday, July 24th, afternoon and evening. A fine supper will be served from five o'clock on. Good music and a large crowd.

We shall be glad to welcome you.

Cordially,

Hightstown, N. J.
July 20, 1907.

R. W. Swetland
For the Committee.

This postcard announcement of the Harvest Home of the Hightstown Baptist Church invited the recipient to attend a fine supper on July 24, 1907, in the grove behind the church (where the church still stands today, on South Main and Main Streets). The invitation was sent by Dr. Roger W. Swetland, the Peddie School's longest serving headmaster (1898–1934), to the Hon. Frank Katzenbach of Trenton. (R&KP)

UNITED STATES OF AMERICA

POSTAGE ONE CENT

THE SPACE ABOVE IS RESERVED FOR POSTMARK.

POSTAL CARD.

THE SPACE BELOW IS FOR THE ADDRESS ONLY.

Hon. Frank Katzenbach.
Trenton,
N. J.

Frank Snowden Katzenbach Jr. (1868–1929) was an American jurist and Democratic party politician from New Jersey. Katzenbach was born in Trenton in 1868. He was nominated for governor in 1907, but ultimately lost the election to John Franklin Fort by a very close margin.

This is a c. 1900 advertisement for J.V. Davison's store. The store was located at the north corner of Main and Stockton Streets. Joseph Van Doren Davison, one of ten children of the Davison family, purchased this building in 1885 from C.W. McMurran and later sold it to his sons in 1906.

By 1938, Hightstown had arrived, with its spacious new post office on South Main Street. Airmail was delivered at the Hightstown Airport, also known as Norcross Field, which was located on Airport Road at the site of the former East Windsor Speedway. In the 1950s, it was a terminal for helicopter airmail delivery from New York City. (R&KP)

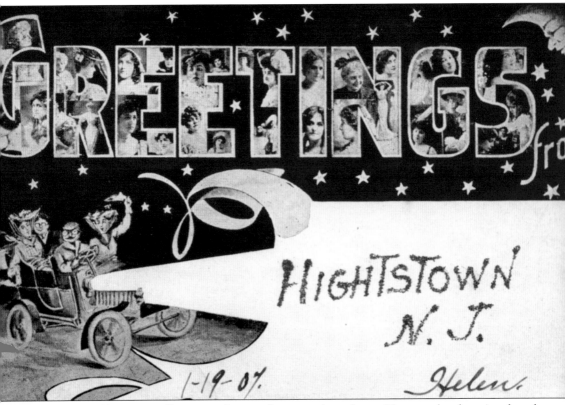

GREETINGS fro HIGHTSTOWN N. J.

1-19-07.

Helen

Postcard collecting is still very much part of our popular culture. There are local, national, and international postcard collecting organizations that sponsor annual shows for buying, selling, and showing every imaginable type of postcard. Postcards are colorful, inexpensive, and easy to find and store, and they often have interesting stamps and postmarks. Their messages can transport one instantly into the past. The postcard allows the traveler to quickly share an image with family and friends, relate the enjoyment and the scenery, and wish them the same travel experience. The postcard hysteria faded by the time World War I began. Most cards between 1915 and 1930 were printed in the United States. Many were reprints of earlier divided back postcards and are distinguished by their white border. The advent of folded greeting cards sold with envelopes resulted in fewer postcards being produced from the 1920s to the 1960s, but they are back in full swing today. While "wish you were here" remains the most popular postcard heading, "greetings from . . ." is no doubt a close second.

This is a present view of the house depicted at the top of page 25. The house is a Colonial Revival style and very different from the original house in that the porch and all the stone supports have been removed. The porte cochere remains a special feature of the home, but it is now supported by slender, paired square columns. Classified as a Colonial Revival dwelling, its proximity to the street, and the Federal-era fanlight over the door, suggest an earlier construction, possibly around 1800. The house was later remodeled by E.T.R. Applegate, a judge of the Mercer County Court of Common Pleas and a New Jersey assemblyman. In 1916, the house was sold to Howard C. Davison, an owner of the J.V. Davison and Sons Dry Goods Store. Howard's daughter Gloria Davison (Orr) was born there in 1925. In 1940, Dr. and Mrs. William G. Rose bought the house and used it for a residence and office until 1981. (RHP)

As evidenced by its lack of dividing line on the rear for message and address, this postcard represents the period between 1870 and 1898; however, it is postmarked 1922. Chas. J. Keeler and Bro. was a hat store in Hightstown, and this postcard is promoting their window display. Imagine how many more people might have visited if they had also included a picture.

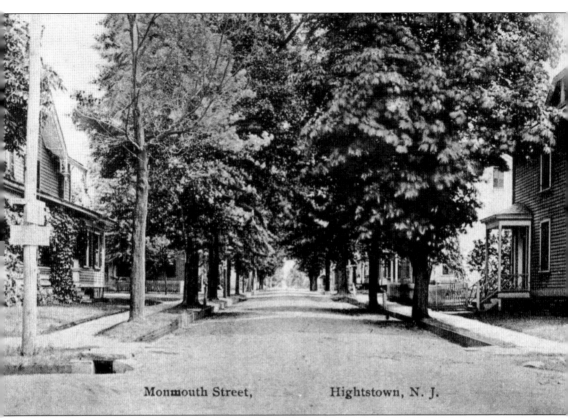

Monmouth Street, Hightstown, N. J.

This is a view from North Main Street looking down Monmouth Street. It shows a narrow road with healthy trees, a far cry from today's view. This postcard was addressed to J.V. Davison in Parkersburg, West Virginia: "Dear Father, I'm leaving the dear old home [in Hightstown, pictured here on the left] this afternoon. Wish you were going to be at Phila. like you were last time when my train pulled out. I've had a lovely visit home and will look forward to Christmas time. Lots of Love, Florence [Davison]." Just think how nice it would be to walk down the street or take a short carriage ride to the passenger train station and get onto a train into Philadelphia or "the City" (New York City), as some postcards refer to it. There were no traffic or parking problems in Hightstown, just beautiful vistas of the lake, walkable neighborhoods, and friendly people along the sidewalk.

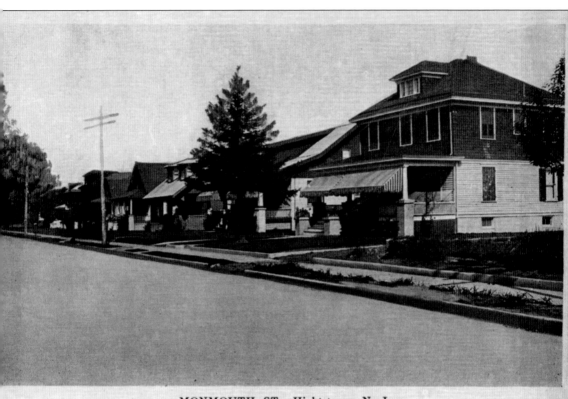

MONMOUTH ST., Hightstown, N. J.

This image of the east end of Monmouth Street (near East Windsor Township) shows wonderful period examples of both a Foursquare-form house and bungalows. The Foursquare is a form to which several styles were incorporated. The Foursquare form was a reaction to the ornate and mass-produced elements of the Victorian styles, and was also considered very economical to build. This form of house sprang up between 1890 and 1930. In Hightstown, there are many fine examples. The smaller bungalows came later in the century. They were built between 1905 and 1930, typically in the Arts and Crafts style. Bungalows usually have a low-pitched gable or hipped roof, deep eaves with exposed rafters, and decorative knee braces, and are one and one-half stories tall. Inside, one would find a lot of fine woodwork. It is likely that the Foursquare was the last house on the block for many years and that the bungalows were built later, possibly due to the influx of workers at the Hightstown Rug Mill.

R.R. Priest of Hightstown took this portrait. When photography was first invented in 1839, a person had to stay still for almost 20 minutes to be photographed. Within a year, this time had been cut to two minutes, then to half a minute and less. But even 30 seconds is a long time to sit totally still. The chair is likely there to help stand still. Try standing completely still for 30 seconds without something to hold onto.

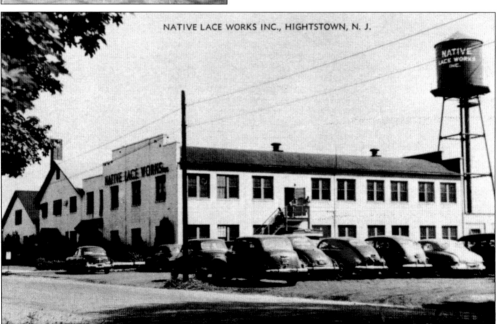

Native Lace Works (now Empire Antiques) was one of the industries flourishing in Hightstown 70 years ago. It employed over 200 people. Industry was the third pillar of strength for Hightstown. The stores and businesses were nourished by the farm income. The largest and most widely known business was the Hightstown Rug Company. The Farm Fresh Canning Corporation also employed 100 people, particularly when the blueberry and cranberry crops were in. (R&KP)

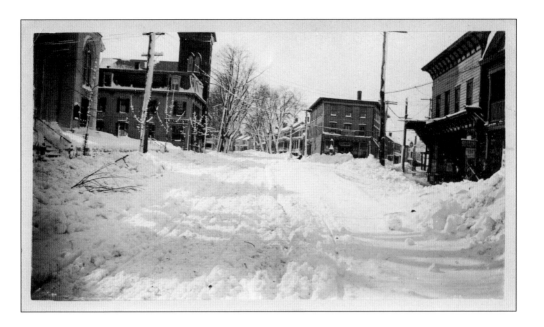

The *Hightstown Gazette* from March 4, 1914, featured the headline "Big Snow Storm Held Up Trains, Communication by Wire Cut Off by Blizzard, which was the Worst Since 1888." It was the biggest snowstorm in this section of the country in more than 25 years. It began on the morning of Sunday, March 3, 1914, and lasted until Monday afternoon, practically isolating Hightstown and cutting off all communications, as well as preventing travel for three days. The high winds caused large drifts as high as eight feet. No trains came into town until Tuesday, March 5, 1915. The wires of the Hightstown Electric Company were down in many sections by Sunday night. Food supplies were low at homes and stores. Deliveries of coal were not available until Tuesday, and mail was delayed for several days. (R&KP)

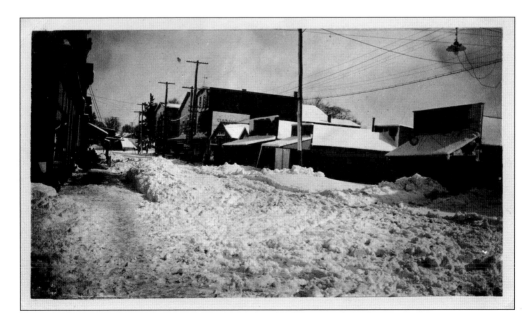

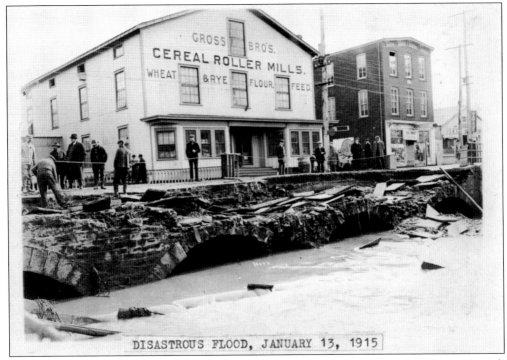

DISASTROUS FLOOD, JANUARY 13, 1915

According to the *Hightstown Gazette* article "Storm and Flood Do Much Damage, High Water Floods Business District Causing Big Loss, A Steady Stream of Water Flows Through Downtown" from March 5, 1915, an overabundance of water flooded lower Hightstown on the evening of Wednesday January 13, 1915. Main Street was underwater with flooding received from Ogborn's Oyster Shop, Coward's Restaurant, Bard's Tailor Shop, Gross Brothers' Mill, the Electric Movie Theatre, Dennis' Garage, and Child's Grocery Store. Main Street's bridge over the Rocky Brook was damaged, too. The water reached its highest level about nine o'clock that night. Even the wastewater treatment plant's operation was flooded at the end of Oak Lane where the Rocky Brook passes. History repeated itself many times through 2011 with heavy flooding that has disrupted Hightstown's business district. (R&KP)

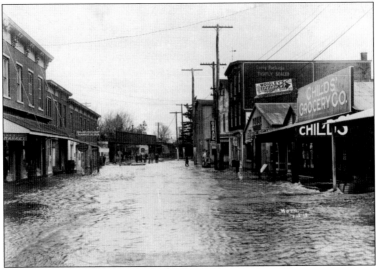

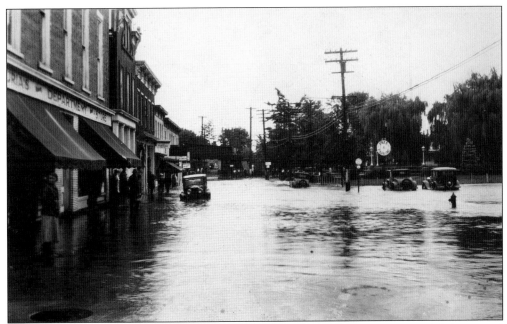

According to the *Hightstown Gazette* of September 20, 1934, there was a heavy rainfall that started shortly after midnight Sunday, September 17, and continued until noon on Monday, September 18. The dam at Rocky Brook in Perrineville gave way at 8:00 a.m., and two hours later, the Hightstown dam was overwhelmed. The water flowed over the wall and into downtown Hightstown and was up to two feet deep in places. Sidewalks, the railroad trestle abutments, and the archway over the Rocky Brook were damaged. The Allen & Stults Company's cellar filled with water. Most of the stores were damaged, and the firehouse had water on its first floor. Over the last 100 years, there have been many floods. In 2011, Tropical Storm Irene dropped over five inches of rain, which flooded Borough Hall and resulted in its permanent closure. (R&KP)

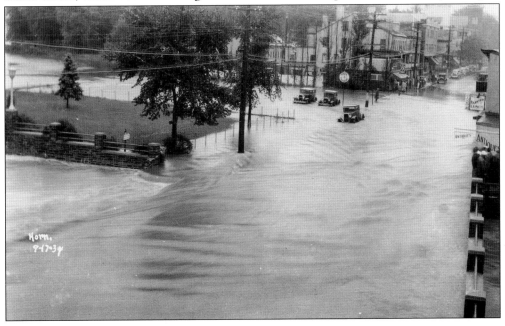

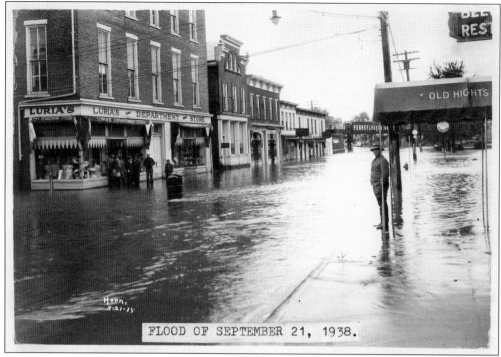

FLOOD OF SEPTEMBER 21, 1938.

The flood of September 21, 1938, was four years and three days after the flood on September 17–18, 1934, that left most of the downtown commercial buildings damaged. The image below was taken from the railroad trestle spanning North Main Street and Rocky Brook. It shows the dam's spillway on the immediate left and Main Street flooded to the south and past the municipal parking lot, the Old Hight's Restaurant, and the First National Bank. The First Baptist Church, which was on high ground, is seen towering in the background. Local photographer David F. Horn took these photographs. (R&KP)

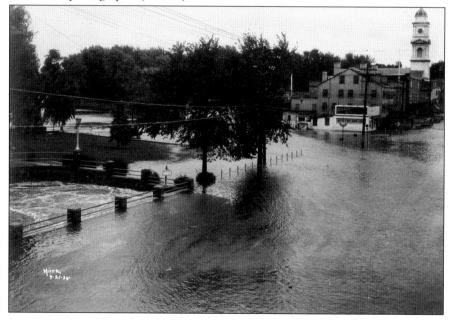

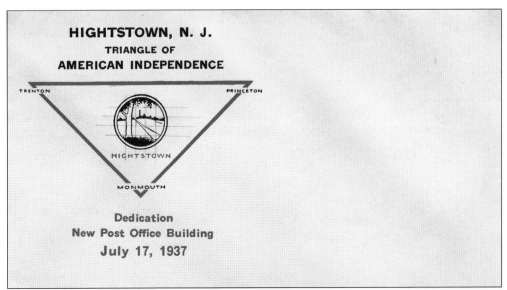

In October 1921, Hightstown marked its bicentennial with a weeklong celebration and an enormous parade. The occasion was noted nationwide in the news media: "Hightstown, situated in the center of the great triangle formed by the great battlefields of Trenton, Princeton, and Monmouth, has been honored with the title of 'The Shrine of American Independence.' " (R&KP)

Patience Track, a black woman, was born a slave and died a free woman. She is buried in the East Windsor Cemetery. She arrived as a refugee at the Aaron Ely house, a way station on the Underground Railroad. Ely paid to free her, after which she decided to stay on as a domestic. When Ely died in 1863, he left money to support Track for the rest of her life. (R&KP)

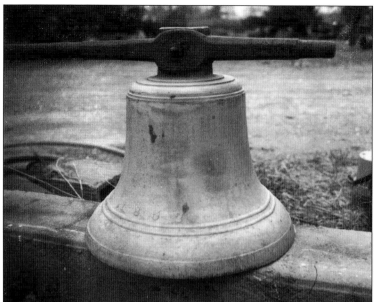

The Hightstown Academy Bell was added to the Academy building on Mercer Street in 1852. Peter Ely solicited public contributions to raise money for the bell. It is inscribed, "J. Benson, 1852." In 1895, the bell was placed in the belfry of the new Mercer Street School, which was erected on the site of the old Academy. (R&KP)

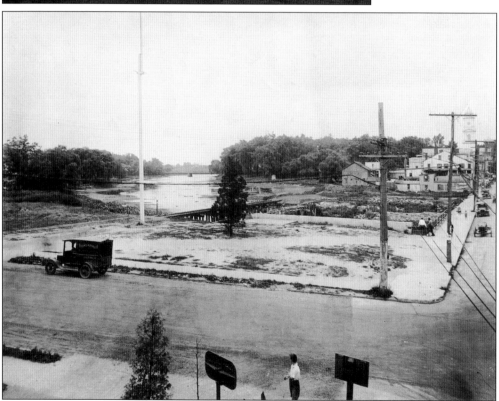

After the cereal mill fire on May 29, 1920, all of the buildings in what is now Memorial Park had burned down. This photograph was taken from the train trestle at Franklin Street and North Main Street, and it shows the 100-foot flagpole that was erected in October 1921 to honor the veterans of Hightstown, the old footbridge across the dam, and an early view of the lake—before the stone walls were built.

BIBLIOGRAPHY

Evans, William K. *Princeton, A Picture Postcard History of Princeton and Princeton University*. New York: Almar Press, 1993.

Fenity, Leo W. *Portrait of Two Suburban Dairies: Davison's Dairy and Decker's Dairy, Hightstown, N.J.* Cranbury, NJ: July 1998.

Green, Edward T. *Oration Delivered before the East Windsor Soldier's Monument Association at Hightstown, N.J., July 5th, 1875*. Trenton, NJ: 1875.

Hightstown–East Windsor Historical Society Library. Hightstown, NJ

Hightstown Mercer County New Jersey Map, June 1916. New York: Sanborn Map Company, 1916.

History of the First Presbyterian Church, Hightstown, New Jersey, 1857–1957. Hightstown, NJ: The First Presbyterian Church, 1957.

History of the First United Methodist Church of Hightstown. Hightstown, NJ: 1984.

Middleton, Kathleen M. *East Windsor Landmarks*. Princeton Junction, New Jersey: PDQ Press, 1997.

Orr, John W. Jr. *Reflections from the Shrine, an Anecdotal History of Hightstown and East Windsor*. Hightstown, NJ: Longstreet House, 1998.

Pratt, Richard Harlan. *A Guide to the Architecture of Hightstown Houses*. Charleston, SC: CreateSpace, 2012.

Pullen, Ida Martin. *Family History of John Hight, Founder of Hightstown*. Hightstown, NJ: Reprinted by the Hightstown–East Windsor Historical Society, Booklet No. 1, 1985.

Seventy-five Years of Faithful Service 1870–1945: The First National Bank of Hightstown, New Jersey. Compiled by John W. Perrine. Trenton, NJ: The Smith Press.

Stockton Street Historic District Application Project, Application to the National Register of Historic Places. Hightstown, NJ: Compiled by the Borough of Hightstown.

The Hightstown Gazette. Hightstown, NJ.

DISCOVER THOUSANDS OF LOCAL HISTORY BOOKS
FEATURING MILLIONS OF VINTAGE IMAGES

Arcadia Publishing, the leading local history publisher in the United States, is committed to making history accessible and meaningful through publishing books that celebrate and preserve the heritage of America's people and places.

Find more books like this at
www.arcadiapublishing.com

Search for your hometown history, your old stomping grounds, and even your favorite sports team.

Consistent with our mission to preserve history on a local level, this book was printed in South Carolina on American-made paper and manufactured entirely in the United States. Products carrying the accredited Forest Stewardship Council (FSC) label are printed on 100 percent FSC-certified paper.

MADE IN THE USA